RUNNING FOR

Candidates, Campaigns, and the Cartoons of Clifford Berryman

OFFICE

By Jessie Kratz and Martha Grove

With a Message from Allen Weinstein, Archivist of the United States

Foreword by Harry Reid, Senate Majority Leader, and
Mitch McConnell, Senate Republican Leader

Philip Wilson in collaboration with
The Foundation for the National Archives, Washington, DC

This book is based on the exhibition "Running for Office: Candidates, Campaigns, and the Cartoons of Clifford Berryman," presented at the National Archives, Washington, DC, in the Lawrence F. O'Brien Gallery from February 8, 2008, to August 17, 2008.

Library of Congress Cataloging-in-Publication Data

United States. National Archives and Records Administration.

Running for Office : Candidates, Campaigns, and the Cartoons of Clifford Berryman / by Jessie Kratz and Martha Grove ; with a message from Allen Weinstein ; foreword by Harry Reid and Mitch McConnell.

p. cm.

"Based on the exhibition 'Running for Office: Candidates, Campaigns, and the Cartoons of Clifford Berryman,' presented at the National Archives, Washington, DC, in the Lawrence F. O'Brien Gallery from February 8, 2008, to August 1, 2008"—T.p. verso.

ISBN 978-0-85667-652-9 (hardcover)—ISBN 978-0-9758601-6-8 (softcover)

1. Presidents—United States—Election—History—20th century—Caricatures and cartoons—Exhibitions. 2. Political campaigns—United States—History—20th century—Caricatures and cartoons—Exhibitions. 3. United States—Politics and government—20th century—Caricatures and cartoons—Exhibitions. 4. Berryman, Clifford Kennedy, 1869–1949—Exhibitions. 5. United States. National Archives and Records Administration— Exhibitions. I. Kratz, Jessie. II. Grove, Martha, 1965–III. Foundation for the National Archives. IV. Title.

JK524.U6 2008

324.973'091—dc22

2007035763

Unless otherwise noted, all cartoons are from the U.S. Senate Collection, Center for Legislative Archives, National Archives

First published in 2008 by
Philip Wilson Publishers
109 Drysdale Street
The Timber Yard
London N1 6ND
www.philip-wilson.co.uk

in collaboration with
The Foundation for the National Archives
700 Pennsylvania Avenue, NW
Washington, DC 20408-0001
www.archives.gov

Distributed throughout the world
(excluding North America) by
I.B. Tauris & Co. Ltd
6 Salem Road, London W2 4BU

Distributed in North America by
Palgrave Macmillan
A division of St Martin's Press
175 Fifth Avenue, New York, NY 10010

Copyright © 2008 The Foundation for the National Archives
Washington, DC 20408-0001
ISBN 978-0-85667-652-9
(hardcover edn.)
ISBN 978-0-9758601-6-8
(softcover edn.)

Printed in China

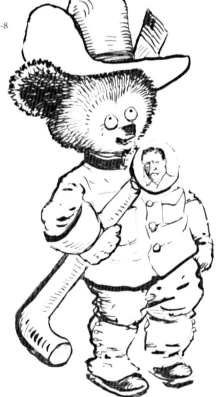

TABLE of CONTENTS

MESSAGE FROM THE ARCHIVIST

Allen Weinstein, Archivist of the United States

In the early 1990s, approximately 2,400 of renowned cartoonist Clifford Berryman's original pen-and-ink drawings were discovered in the basement of his late daughter, Florence. Depicting over half a century of local and national political events, the cartoons spanned Berryman's career as the preeminent Washington political cartoonist from the 1890s until his death in 1949. The Charles Engelhard Foundation, recognizing the historic significance of the collection, purchased the drawings from Florence Berryman's estate. The Engelhard Foundation donated the collection to the U.S. Senate, which in turn transferred them to the National Archives to be housed with the official records of the Senate.

The cartoons selected for this exhibit and publication focus on the campaign process. Remarkably, though we are separated from Berryman's protagonists by more than half a century, the political processes he documented are as current as today's headlines. From the decision to throw one's hat in the ring, to the candidates angling for votes, and to election-day anxieties, the nation's political rituals have remained remarkably consistent. Clifford Berryman's cartoons capture enduring traditions of the campaign trail that are so intricately tied to our system of American democracy.

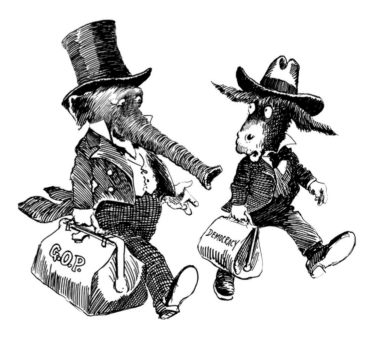

The Berryman cartoons are part of the official records of the U.S. Senate housed in the Center for Legislative Archives at the National Archives in Washington, DC. Since the First Congress in 1789, the records of the U.S. House of Representatives and the U.S. Senate have documented the history of the legislative branch. These records remain the legal property of the House and Senate but are preserved and made available by the Center for Legislative Archives. At the time that the Berryman drawings were acquired by the Senate, the gift was designated in honor of former Senate Majority Leader Mike Mansfield, the longest-serving majority leader in the history of the Senate. We are very proud to honor Senator Mansfield and want to thank our friends on both sides of the aisle in the U.S. Senate, by sharing this special legacy with the American people.

At the National Archives, we preserve our nation's most cherished documents, including the Declaration of Independence, the Constitution, and the Bill of Rights. But these great Charters are only one small part of more than 10 billion records in our care: photos and maps, films and databases, treaties and pension files, and—yes—political cartoons. All of these records reinforce our personal connections to a shared American heritage.

Allen Weinstein
Archivist of the United States

FOREWORD

Harry Reid, Senate Majority Leader
Mitch McConnell, Senate Republican Leader

A sense of humor is a prerequisite for running for public office. Candidates and elected officials must expect to be caricatured by editorial cartoonists, sometimes with very pointed pen. Throughout American history, the art of editorial cartooning has flourished not only because it is entertaining but because it is healthy for the political process for people to be able to chuckle from time to time over what their government is doing. Political cartoonists have been recording the leaders of the American Republic since the days of Washington, Adams, and Jefferson, and by the 20th century that tradition was being carried on by the gifted artist Clifford Berryman, whose work stretched from the era of Grover Cleveland to Harry Truman.

Operating in the national capital as the front-page cartoonist for the *Washington Evening Star,* Clifford Berryman showed a knack for combining accurate likenesses of his political subjects with fanciful poses, employing gentle humor and sympathetic insight. Berryman is best remembered for originating the teddy bear, in honor of the bear that President Theodore Roosevelt declined to shoot on one of his hunting trips. His sketches launched both a beloved stuffed toy for generations of children and an enduring logo for his own work. The cartoonist devoted his attention to Congress as well as to Presidents, and captured so many legislators with his artwork that the bulk of his collection is rightfully housed at the Center for Legislative Archives within the National Archives.

The Center's exhibit is designed to highlight Clifford Berryman's contributions to American political history. We trust that scholars and citizens will find lasting value in his cartoons, as a window to view how our political predecessors campaigned for office over the five critical decades from the Progressive Era through the First World War, the Roaring Twenties, the Great Depression, the Second World War, and the Cold War.

We can smile and wince at how Berryman captured the many colorful personalities and tweaked some of the pretensions of those who led our nation through those trying times. His cartoons remind us that one of the greatest distinctions between a free society and a dictatorship is the ability to express political humor openly and candidly. Back in the 1920s when Berryman's cartoons were appearing daily in the *Star,* Speaker of the House Nicholas Longworth said he never took criticism of Congress personally. He had read enough history to know that it had been going on since the days of John Quincy Adams and Henry Clay. "From the beginning of the Republic," he asserted, "it has been the duty of every free-born voter to look down upon us, and the duty of every free-born humorist to make jokes at us." Editorial cartoonists such as Clifford Berryman have served the national interest by putting politicians in perspective, and at that Berryman was a master of the craft.

Harry Reid
Senate Majority Leader

Mitch McConnell
Senate Republican Leader

ACKNOWLEDGMENTS

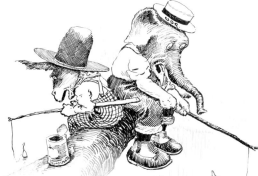

The exhibit "Running for Office: Candidates, Campaigns, and the Cartoons of Clifford Berryman" and accompanying publication are truly a collaboration of many individuals.

The exhibit and catalog were created under the direction of Michael J. Kurtz, Assistant Archivist for Records Services—Washington, DC; Marvin Pinkert, Director of the Center for the National Archives Experience; and Christina Rudy Smith, Head of Exhibits, who also served as an outstanding exhibit manager.

Our colleagues at the Center for Legislative Archives were instrumental in both the conception and execution of the exhibit. Special thanks go to Allison Noyes, Christine Blackerby, Kenneth Kato, and Judith Adkins, and especially to Director, Richard Hunt, and Assistant Director, Matt Fulgham. The Center's interns—Katharine Kipp, Charles Delgadillo, Timothy Conrad, Benjamin Eppler, and Erin Kwiatkowski—were invaluable in performing background research.

Running for Office was published with the support of the Foundation for the National Archives. We would like to acknowledge Executive Director Thora Colot, Director of Marketing and Administration Franck Cordes, Director of Development Stefanie Mathew, Publications and Research Manager Christina Gehring, and Grants and Research Manager Dan VanHoozer, for their help making the exhibit and publication possible.

Thanks also to the talented Brian Barth who designed the publication and to Maureen MacDonald who painstakingly edited both the exhibit text and the catalog. The elegant exhibit design is the work of Michael L. Jackson. James Zeender and Karen Hibbitt served as the exhibit registrars, and Terry Boone and Yoonjoo Strumfels performed the necessary conservation work on the cartoons. Other colleagues—Stacey Bredhoff and Bruce Bustard—graciously lent their extensive exhibit experience.

Jeff Reed, Steve Puglia, Jennifer Seitz, and Amy Young of the National Archives digital and photographic labs helped produce scans for the exhibit and book. Nick Natanson, Ed McCarter, and Holly Reed from the still pictures staff were particularly knowledgeable and helpful with researching photographs.

We also appreciate the efforts of David McMillen, External Affairs Liaison; Susan Cooper, Director of Public Affairs; and Laura Diachenko, Miriam Kleiman, and Kate Slaugh—all members of the public and congressional affairs staff, for publicizing the exhibit to the press, public, and those on the Hill.

Outside of the National Archives, former colleagues Ida Brudnick and Katherine Brasco both offered their extensive knowledge of Clifford Berryman and the collection. Mark Greek from the Washingtoniana Division of the DC Public Library, Barbara Bair at the Library of Congress, and Wendy Hurlock Baker at the Smithsonian Institution's Archives of American Art also made valuable contributions. We would like to express our particular appreciation to Zack Wilske, who reviewed the exhibit and catalog text and helped in countless other ways, and to Paul Grove, who provided much-needed support and encouragement.

We are also grateful to the Secretary of the Senate, Nancy Erickson; Senate Curator, Diane Skvarla; Senate Historian, Richard Baker; and their staffs. The catalog and exhibit would not be possible without their interest and support.

We give special thanks to Harry Reid, Senate Majority Leader, and Mitch McConnell, Senate Republican Leader, for contributing the foreword to this work. Finally, we can't express enough gratitude to the U.S. Senate for acquiring the extraordinary Clifford Berryman Collection and ensuring its permanency by having it housed at the Center for Legislative Archives.

Jessie Kratz and Martha Grove
Center for Legislative Archives

The political cartoons in this catalog and the exhibit on which it is based were drawn during the first half of the 20th century by Washington cartoonist Clifford K. Berryman. While Berryman's cartoons highlighted issues of local, national, and international importance, the cartoons featured here focus specifically on the campaign process in the United States.

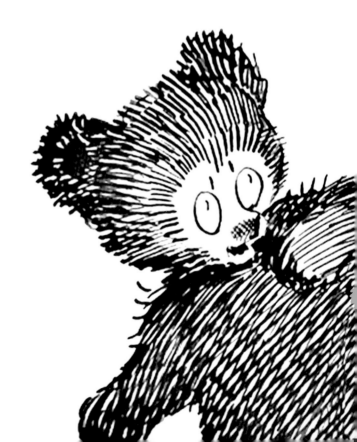

INTRODUCTION

Political cartoons are unlike any other form of political commentary. Visual in nature, cartoons exaggerate physical traits and emphasize small details to make specific points. With simple pen strokes, they foreshadow the future, poke fun at the past, and imply hidden motives in a subtle fashion impossible to achieve with written or spoken reporting. The result of this creative license is a unique historical perspective that is as entertaining as it is insightful.

The political cartoons in this catalog and the exhibit on which it is based were drawn during the first half of the 20th century by Washington cartoonist Clifford K. Berryman. While Berryman's cartoons highlighted issues of local, national, and international importance, the cartoons featured here focus specifically on the campaign process in the United States. Each section of the exhibit catalog highlights a step of the campaign process, beginning with the candidate's decision to enter the race and ending with his or her election-day triumph or defeat. While in some cases the specific events that inspired Berryman occurred more than a century ago, his cartoons often convey a sense of knowing insight into the world of politics today.

Each of the featured cartoons first appeared on the front page of Washington newspapers between 1898 and 1948. Because Berryman often gave away his cartoons, many of his original drawings are now scattered throughout numerous locations, but the original drawings featured in this catalog are part of the largest collection of Berryman's cartoons housed in a single location. Originally belonging to Berryman's daughter, this rare collection was purchased by the Charles Engelhard Foundation and donated to the U.S. Senate.

The Clifford Berryman Collection is now part of the historical records of Congress in the Center for Legislative Archives at the National Archives in Washington, DC. The political cartoons in the Berryman Collection, which provide a sometimes biting, sometimes sympathetic, but always entertaining, insider's view of life in Washington, are the perfect complement to the official records of Congress. Berryman's cartoons add unique and unparalleled insight into the major figures and events of his era and the National Archives is truly fortunate to be able to share them with the public.

REPRODUCING CARTOONS
IN NEWSPAPERS

Berryman's original cartoons are much larger than they appeared in newspapers. In most cases the original drawings are as big as an entire newspaper page. To reproduce a cartoon for publication in the newspaper during much of Berryman's era, the original was photographed and a negative was made. The negative was then projected onto an engraving plate and reduced to fit the allotted space in the newspaper. An engraver traced the image onto a printing plate by etching the metal with powder or acid. The plate was then used to print the image.

Front page of the *Washington Evening Star,* March 4, 1920

Martin Luther King Jr. Memorial Library
District of Columbia Public Library

Evening Star.

WITH SUNDAY MORNING EDITION

ON, D. C., THURSDAY, MARCH 4, 1920—THIRTY-TWO PAGES.

HOW HIS VOICE HAS CHANGED!

WINTER'S HARDEST STORM HITS WEST

Blizzard Sweeps Eastward,

INTERNATIONAL LOAN FOR GERMANY GETS O. K.

LONDON, March 4.—The Even-
ing Standard states today that the
allied supreme council has decided
to allow Germany to launch an inter-
national loan, because it is recog-

NEW JERSEY SEEKS TO END DRY LAW

Asks That the Prohibition

CLIFFORD K. BERRYMAN
Political Cartoonist Extraordinaire

Clifford Kennedy Berryman was born in 1869 in the village of Clifton near Versailles, Kentucky. While growing up, drawing was one of Berryman's favorite pastimes, and he regularly sketched friends, animals, and even local politicians. His work attracted the interest of Kentucky Senator Joseph C. S. Blackburn, who happened to see one of Berryman's sketches displayed in a local office building. Recognizing Berryman's talent, Blackburn helped secure Berryman a position as a draftsman at the U.S. Patent Office. And so in 1886, at the age of 17, Berryman moved from Kentucky to Washington, DC, where he used his self-taught talents to draw patent illustrations.

Berryman left the Patent Office in 1891 to become a cartoonist's understudy for the *Washington Post*. Within five years, Berryman had risen to chief cartoonist, a position he held until 1907 when he became the front-page cartoonist at the *Washington Evening Star*, then the most widely read newspaper in Washington. Berryman drew political cartoons for the *Star* until his death in 1949 at the age of 80.

Washington political circles embraced Berryman's cartooning. Throughout his extraordinary career, he drew every Presidential administration from Grover Cleveland to Harry Truman. He satirized both Democratic and Republican political figures but never used outlandish caricature, which won him great respect from many politicians. With brilliantly simple pen strokes, Berryman created exacting portraiture that was both flattering and true to his subjects. Included in this catalog are photographs of some of the well-known politicians portrayed in the cartoons. These illustrate the accuracy of Berryman's likenesses.

Berryman is most celebrated for his November 16, 1902, *Washington Post* cartoon, "Drawing the Line in Mississippi," which portrayed an image of the teddy bear for the first time. By some estimates, Berryman drew over 15,000 cartoons in his lifetime and his work was formally recognized in 1944 with a Pulitzer Prize for editorial cartooning. In 1949, President Harry Truman honored Berryman with a well-deserved compliment: "You are a Washington Institution comparable to the Monument."

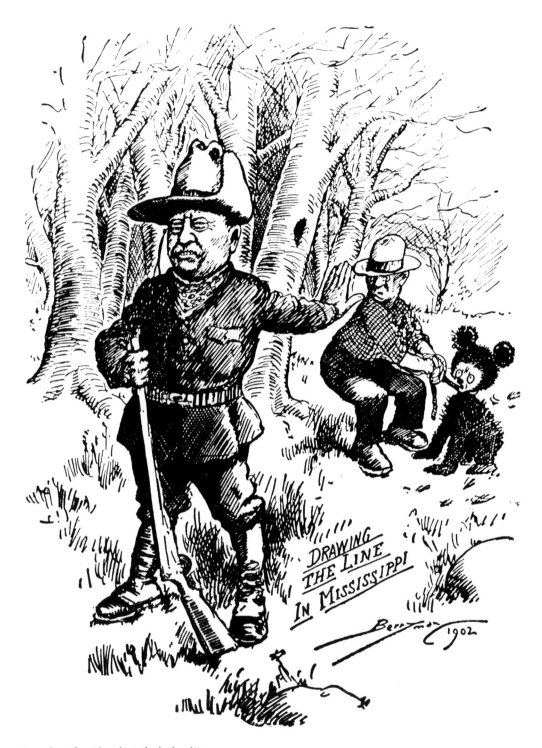

"Drawing the Line in Mississippi"

By Clifford Berryman, 1902. *Courtesy of the Berryman Family Papers, 1828–1984*

Archives of American Art, Smithsonian Institution

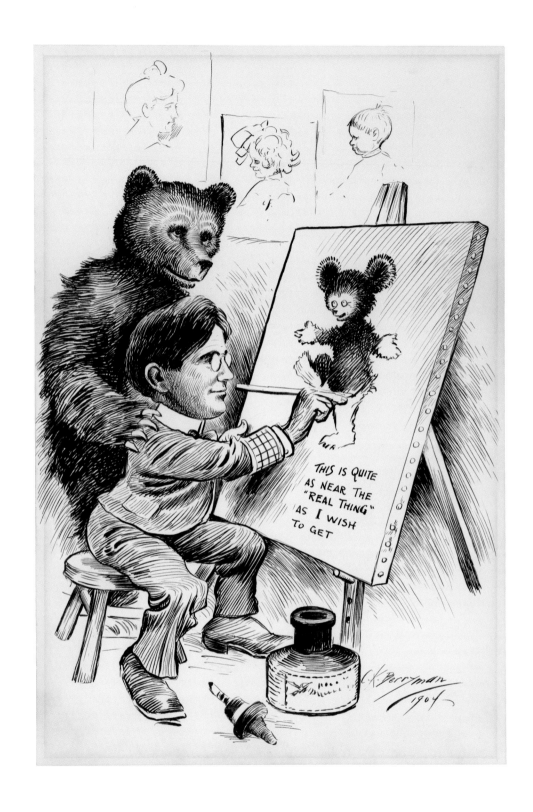

THIS IS QUITE
AS NEAR THE
"REAL THING"
AS I WISH
TO GET

Portrait of Clifford K. Berryman
By Harris & Ewing, undated
U.S. Senate Collection
Center for Legislative Archives

***Opposite:* Self-portrait, 1904**

Clifford Berryman is credited with introducing the teddy bear into American vernacular after President Theodore Roosevelt famously refused to shoot an old, haggard bear during a hunting trip. Berryman changed the old bear into a cute, cuddly "teddy bear"—named for the President—and it became a common symbol in Berryman's cartoons. This cartoon shows a self-portrait of Berryman drawing his famous teddy bear.

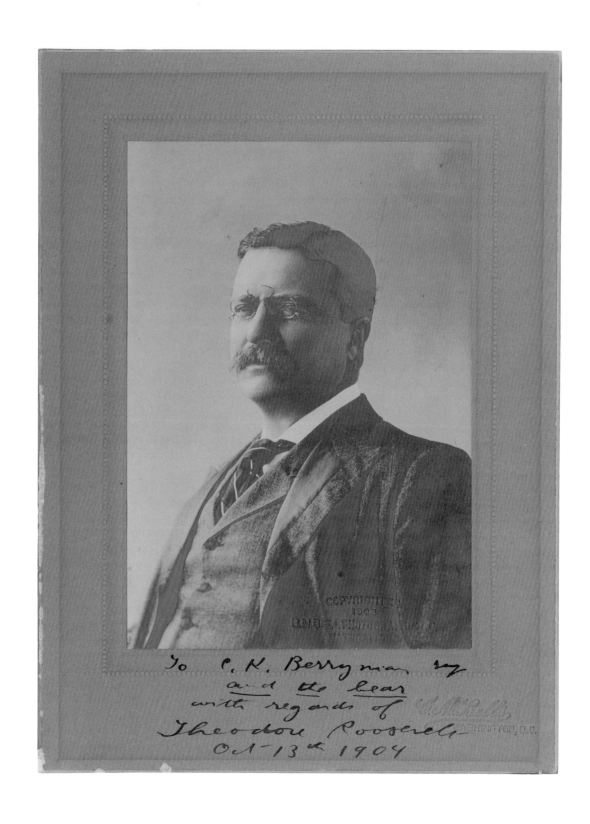

To C. K. Berryman *Esq*
and the bear
with regards of
Theodore Roosevelt
Oct 13th 1904

8

Original photograph of Theodore Roosevelt,
by C. M. Bell Photographic Company, signed October 13, 1904

U.S. Senate Collection
Center for Legislative Archives

Clifford Berryman was known for his realistic cartoon portraits that did not
unkindly emphasize or exaggerate the physical traits of his subjects. Among his
papers are hundreds of reference photographs of many of the famous people who
appeared in his cartoons. President Roosevelt gave this photograph of himself
to Berryman. It is signed, "To C. K. Berryman *and the bear* with regards of Theodore
Roosevelt Oct 13th 1904."

CAST OF RECURRING CHARACTERS

Berryman would often use a recognizable figure to convey a common concept. Personification and symbolism are two of the strongest tools available to the political cartoonist.

Teddy Bear

Clifford Berryman is credited with introducing this lasting symbol into the American consciousness. In 1902, President Theodore Roosevelt refused to shoot an old bear during a hunting trip. In his drawings Berryman transformed the old bear into a cute, cuddly "teddy bear"—named for the President. The image not only became a common symbol representing Theodore Roosevelt in Berryman's cartoons, but it also gave rise to the popular stuffed teddy bear. After Roosevelt left office, Berryman continued to use the teddy bear to represent his own personal point of view.

Miss Democracy

Miss Democracy is the personification of the voice or the will of the American people. Berryman often used her to symbolize the mood of the United States.

Uncle Sam

Uncle Sam, who first appeared in political cartoons during the War of 1812, is used by Berryman to personify the United States. He is usually depicted as a lanky man with white hair and a goatee, patriotically dressed in a star-spangled suit and tall top hat. His most famous image is from the "I WANT YOU" World War I Army recruiting poster drawn by James Montgomery Flagg.

John Q. Public

John Q. Public is a generic name in the United States to denote a symbolic member of society deemed a "common man." He has no strong political or social biases and represents the randomly selected "man on the street."

Democratic Donkey

The donkey has become the common symbol of the Democratic Party. It was first associated with Democrat Andrew Jackson's 1828 Presidential campaign. The figure was popularized in the 1870s when it was frequently featured in the cartoons of Thomas Nast.

Republican Elephant

The elephant is a widely recognized symbol of the Republican Party. Made popular by cartoonist Thomas Nast, the Republican elephant first appeared in *Harper's Weekly* in 1874. The Republicans have embraced the elephant as their official symbol and still use it in campaigns today.

The Bee

The bee was a common character in Berryman's cartoons representing political aspirations as the "buzz" in a potential candidate's ear. Berryman used the bee to symbolize the lure of political office.

THROWING YOUR
HAT
IN THE RING!

JIM REED

DAVIS

MCADOO

RALSTON

UNDERWO

Political campaigns begin with a field of candidates who—after much deliberation—declare their interest in pursuing an elected office. In the two-party system, many candidates run to support their party's platform. Some, however, choose to run because they are disappointed with their party's positions and hope to pursue reforms internally. Third-party candidates often run for office to raise awareness about a particular issue or to provide voters more options than the two-party system offers.

When deciding to run in an election, potential candidates must also consider their personal appeal to voters as well as the impact on their family and professional life outside of public service. Would-be candidates know that the publicity of a campaign will showcase their private lives in the public spotlight and that the time commitment will usually require them to put other ambitions on hold. In these cartoons, Berryman captures potential candidates as they consider this decisive first step of the campaign process.

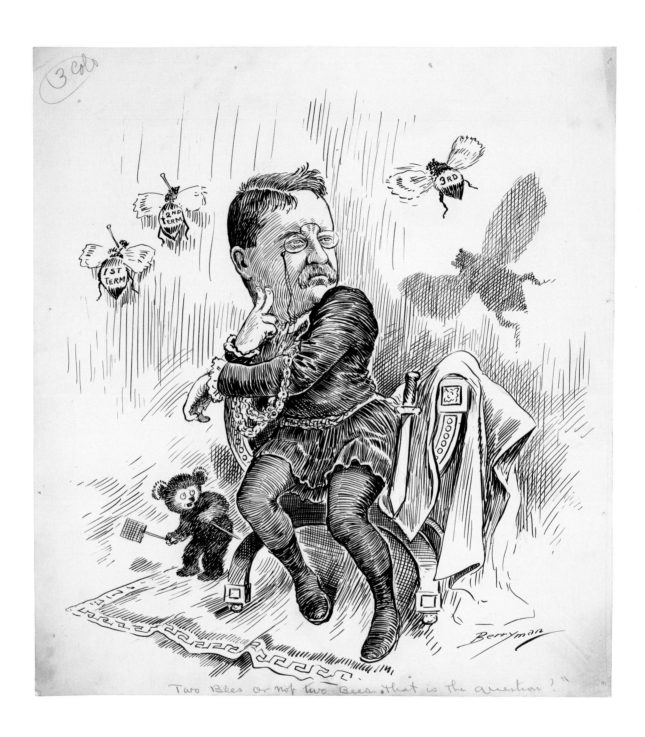

Two Bees or not two Bees that is the question?

President Theodore Roosevelt

By Harris and Ewing, ca. 1901–8

Records of the Office of the Chief Signal Officer

National Archives

***Opposite:* "Two Bees or Not Two Bees—That is the Question! " October 28, 1906**

Theodore Roosevelt was elected Vice President in 1900. Six months into his term, President William McKinley was assassinated, and Roosevelt ascended to the Presidency. After winning the 1904 election, Roosevelt announced he would honor the Presidential two-term tradition by retiring in 1909. However, Roosevelt proved immensely popular and supporters urged him to run for an unprecedented third term of office. In this cartoon Roosevelt, dressed as Hamlet, stages an alternative rendition of the famous Shakespearian soliloquy. With the first- and second-term Presidential bees behind him, Roosevelt looks to the third-term bee and wonders, "Two bees or not two bees—that is the question!" Roosevelt ultimately decided not to run in 1908 and instead left the United States to embark on an extended African safari.

"To Go or Not to Go?"
March 2, 1909

Berryman drew "To Go or Not to Go" just two days before the end of President Theodore Roosevelt's second term in office. As Roosevelt prepared for his African safari, his departure from the White House posed a quandary for Berryman: since Roosevelt was the inspiration for the teddy bear, should Berryman continue to use the symbol once Roosevelt had left office? Much to the delight of the *Star's* readers, Berryman continued the use of the beloved teddy bear throughout his career.

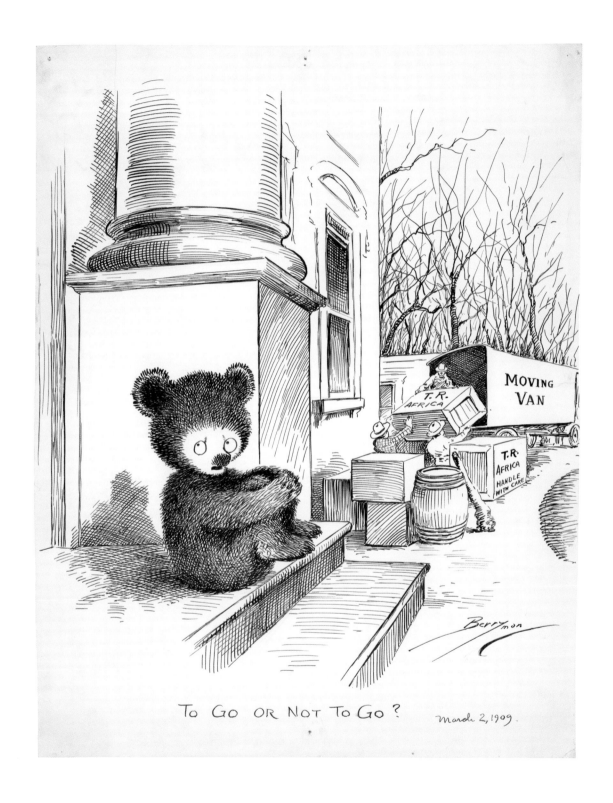

TO GO OR NOT TO GO? March 2, 1909.

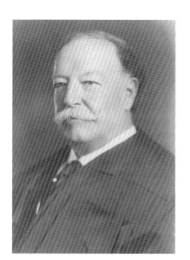

William Howard Taft
ca. 1921–29
Records of the Office of the Chief Signal Officer
National Archives

***Opposite:* "Not Afraid"**
August 9, 1905

As Secretary of War, William Howard Taft told President Theodore Roosevelt that his highest ambition was to serve as Chief Justice of the U.S. Supreme Court. But Roosevelt hoped Taft would run in the 1908 election as his successor if Roosevelt followed through on his promise not to run for President again. With Roosevelt's encouragement, Taft began to consider the option. In this cartoon Taft blocks the buzz of a potential Supreme Court nomination to better hear the enticing buzz of the Presidential bee. Berryman speculates that Taft may be succumbing to Roosevelt's wishes and is "not afraid" of running for President.

William Howard Taft was persuaded by Roosevelt to run for President in 1908 thus deferring his life-long dream. Taft was elected, served one term as President, and lost his bid for reelection in 1912. In 1921, President Warren G. Harding fulfilled Taft's ultimate wish by nominating Taft to be Chief Justice of the U.S. Supreme Court, a position he held until 1930. Taft remains the only former President to serve as Chief Justice of the U.S. Supreme Court.

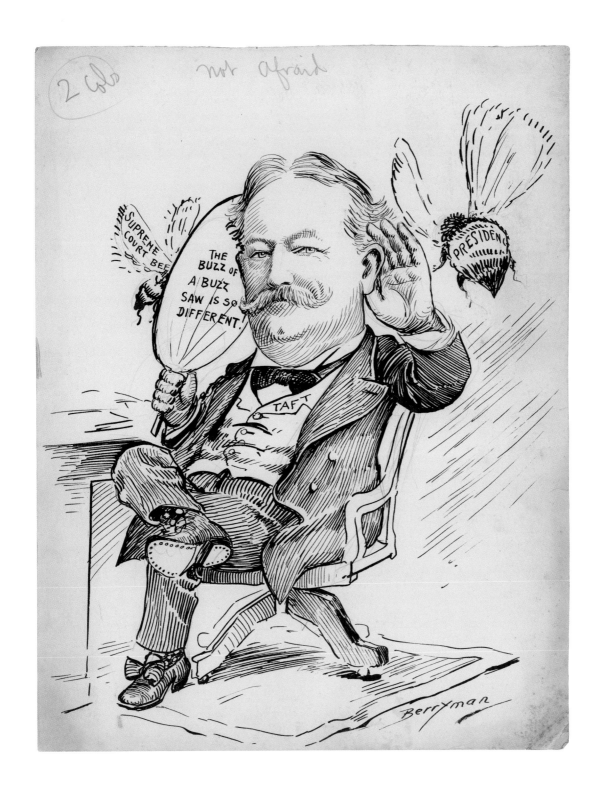

19

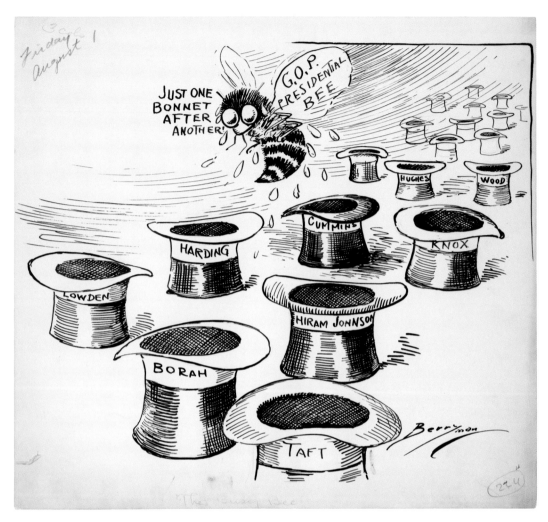

"The Busy Bee"
August 1, 1919

When former President Theodore Roosevelt—the clear favorite for the 1920 Republican Presidential nomination—died suddenly in January 1919, the race became wide open. With such a multitude of potential candidates having the proverbial "bee in their bonnets," the G.O.P. Presidential bee could not keep up. The list of Republican candidates was enormous, including former President William Howard Taft, Senator William E. Borah, Senator Hiram Johnson, Governor Frank O. Lowden, Senator Warren G. Harding, Senator Albert Baird Cummins, Senator Philander C. Knox, former Supreme Court Justice Charles Evans Hughes, and General Leonard Wood. In the end, Harding won the Republican nomination and, with Calvin Coolidge as his running mate, went on to become President.

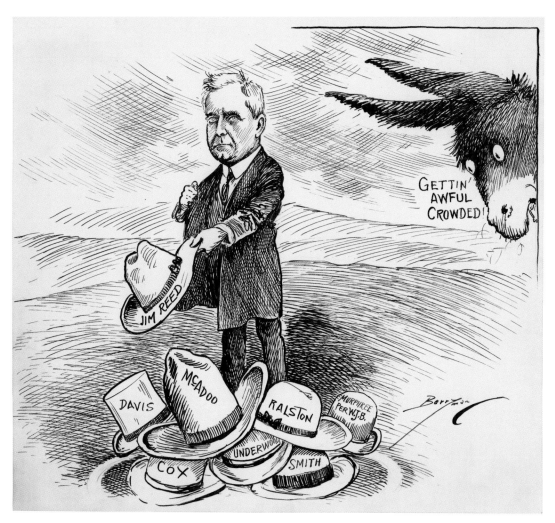

"Gettin' Awful Crowded!"
January 28, 1924

The Democratic race to challenge Republican President Calvin Coolidge in 1924 opened up when front-runner William McAdoo proved weaker than expected. This cartoon comments on the ever-growing field of potential candidates in the months leading up to the Democratic National Convention to be held in New York City. Here Missouri Senator Jim Reed is the latest one to "throw his hat in the ring," while the Democratic donkey worries about the crowded field. At the convention that summer, held at Madison Square Garden, former Ambassador John W. Davis received the Democratic nomination but lost to Coolidge in the November election.

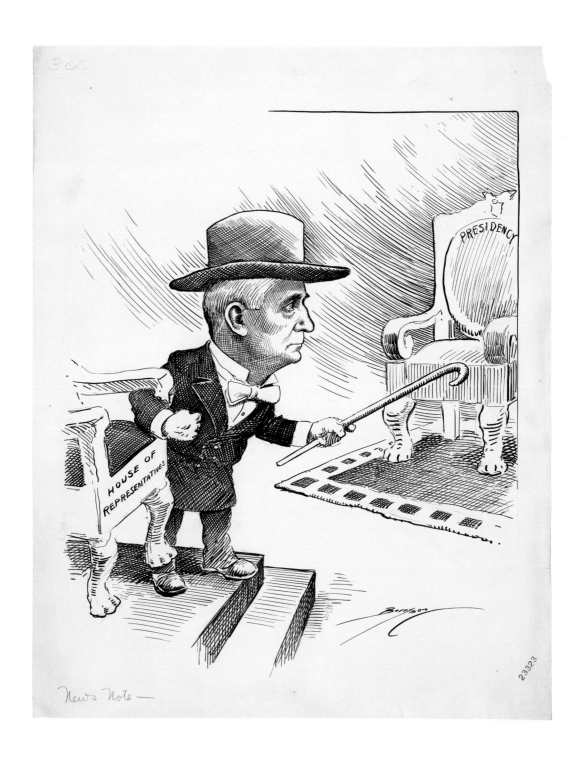

News Note —

Champ Clark
May 25, 1912

Although House Speaker Champ Clark of Missouri was the favorite for the 1912 Democratic Presidential nomination, he also filed a declaration of candidacy for his seat in the U.S. House of Representatives. In this cartoon Clark remains firmly attached to his seat in the House while he reaches for the Presidential chair. This was the first year that the Democrats used primaries to select some of the delegates for the convention, and Clark arrived at the convention with a large number of delegates pledged to him. However, Clark's caution paid off when he lost the Presidential nomination to Woodrow Wilson but won his House seat and secured another term as Speaker.

Henry Ford

By Hartsook Photo, ca. 1920

Prints and Photographs

Library of Congress

Opposite: "Yes, We Have No Ambitions Today!"
July 1, 1928

This cartoon plays off a line from a popular 1923 song, "Yes, We Have No Bananas!" to characterize car maker Henry Ford's Presidential ambitions—or lack thereof. Ford blames his busy schedule for his hesitation to jump into the "Presidential contest pool," while eager supporters encourage him to "come on in!" Berryman was correct in his prediction: Ford, perhaps recognizing that he had little chance of securing a major party nomination, did not pursue the Presidency.

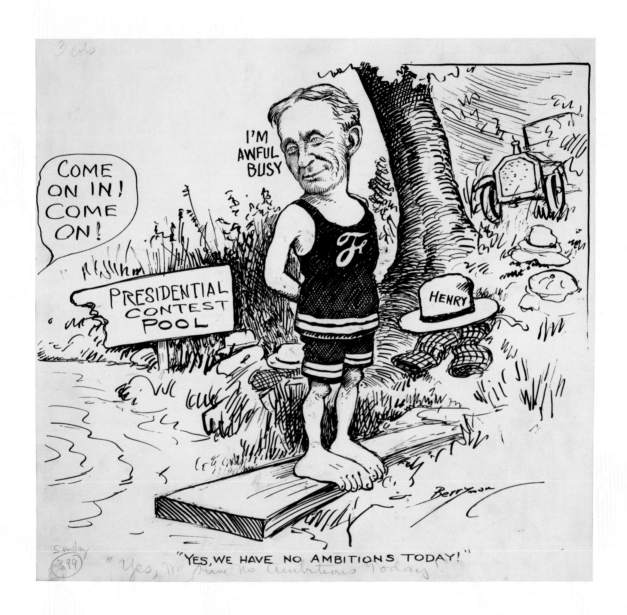

NARROWING THE
FIELD

After potential candidates declare their interest in running for office, each political party determines who receives the party's nomination. In the early 20th century, political machines largely controlled the nomination process, but as Progressive reformers lobbied for greater popular control of the selection process, states began to adopt systems of primary elections. The new primaries shifted the nominating power to the voters.

By the 1912 election, 13 states had enacted some sort of Progressive primary, and by 1920, this number had almost doubled. Many of Berryman's cartoons illustrate nomination contests just as these Progressive reforms had begun to wrest control of the nominating process away from political machines. Although the new system seemed to put a stop to the overt corruption associated with earlier nominating processes, primary elections introduced other difficulties like party divisiveness and interstate competition for influence. Popular primary elections also brought more uncertainty about who the nominee would be—the primaries often did not produce a clear winner, so the candidate was not selected until the party's nominating convention in the summer. Berryman captured many of these events as they unfolded for the first time, yet his insights are relevant to the nominating process today.

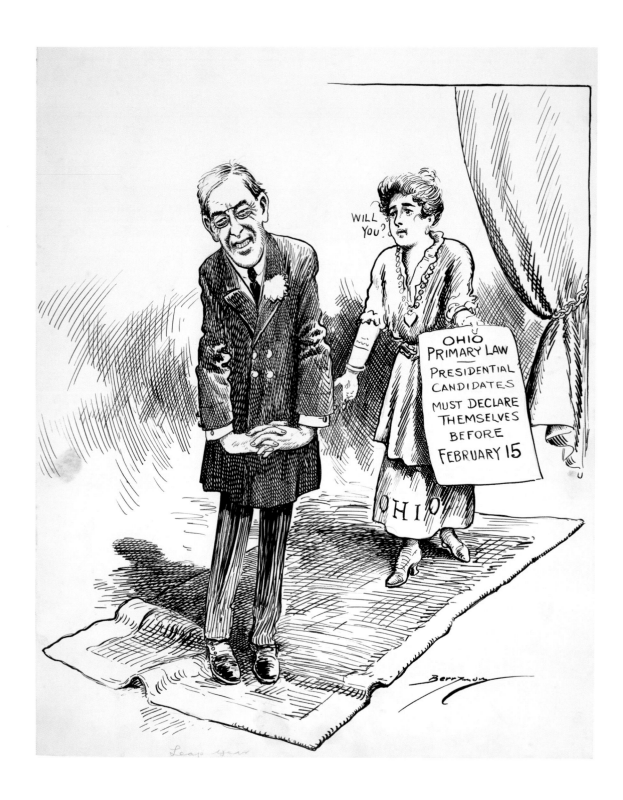

28

Woodrow Wilson

By National Photo Company, ca. 1913–20

Prints and Photographs

Library of Congress

Opposite: "Will You?"

February 7, 1916

As Woodrow Wilson's first Presidential term entered its final year, it was unclear whether he would run for a second term. State primary laws require candidates to declare their intention to run by a particular date, and Ohio's deadline was fast approaching. This cartoon, printed in the weeks leading up to Ohio's filing date, shows Miss Ohio inquiring if a bashful-looking Wilson would declare his candidacy before the state's deadline. Wilson eventually submitted his name to comply with Ohio state law but did not publicly declare his candidacy until later.

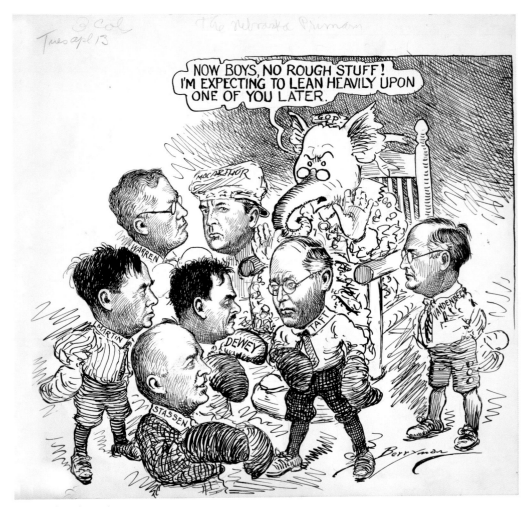

"The Nebraska Primary"
April 13, 1948

Primary elections begin with a large number of candidates, and as the primary season progresses, the field narrows until a single candidate remains. This cartoon shows that large pool near the beginning of the primary season. Printed in the *Washington Evening Star* on the day of the critical 1948 Nebraska primary, the cartoon shows the Republican Party elephant as a watchful mother chastising her "sons" for their bitter infighting. She knows a divisive primary may hurt the prospects of the party's eventual nominee in the general election. The long list of Republican candidates included New York Governor Thomas E. Dewey, former Minnesota Governor Harold E. Stassen, Ohio Senator Robert A. Taft, General Douglas MacArthur, Michigan Senator Arthur Vandenberg, and California Governor Earl Warren. Ultimately, Dewey earned the nomination and with Warren as the Vice Presidential nominee they went on to narrowly lose the general election to Democratic candidates Harry S. Truman and Alben W. Barkley.

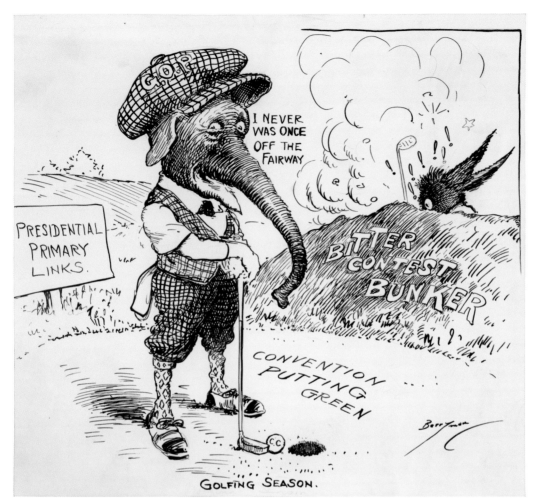

"Golfing Season"
May 1, 1924

The Republicans are not the only party to succumb to divisiveness in a primary season—the Democrats faced the same problem during the 1924 Presidential election. That year Calvin Coolidge, the incumbent President, breezed through the Republican primary unopposed. As the Republicans advanced unscathed to the "convention putting green," the Democratic candidates waged a hostile primary battle "off the fairway." The Democrats finally nominated John W. Davis, an obscure former congressman from West Virginia and former ambassador to Great Britain, as a compromise candidate. Coolidge won the three-way election by a large margin over Davis and Progressive Party candidate Wisconsin Senator Robert M. LaFollette, Sr.

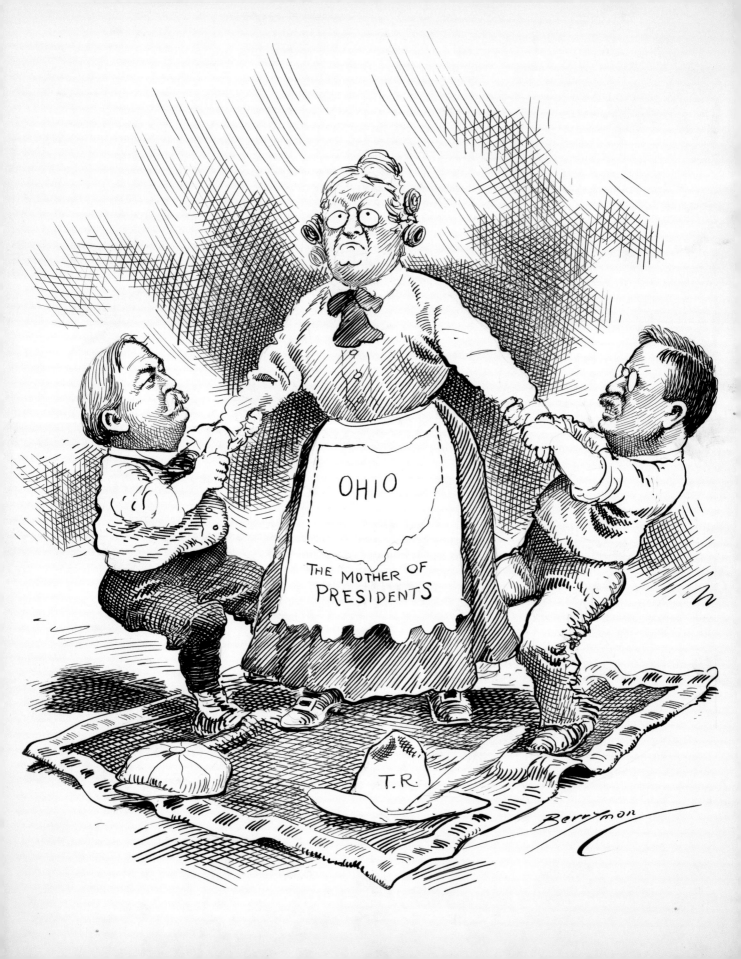

"Ohio—the Mother of Presidents"
May 21, 1912

In 1912 the Republicans used Presidential primaries to choose some of the delegates to their party's national convention for the first time. That year saw former President Theodore Roosevelt returning to challenge the unpopular incumbent President William Howard Taft for the Republican nomination. This cartoon illustrates the critical Ohio primary with Taft tugging on one arm of "mother" Ohio—his birthplace and the home of the most Presidents. Roosevelt is shown tugging on her other arm, hoping to steal her away. Roosevelt handily won the Ohio primary but ultimately lost the Republican Party nomination to Taft. Roosevelt went on to run in the general election as the nominee of the newly formed Bull Moose Party. Both Roosevelt and Taft lost the Presidency to Democrat Woodrow Wilson.

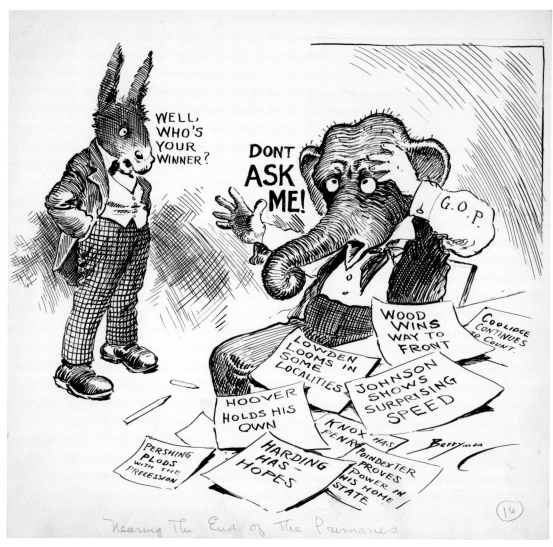

"Nearing the End of the Primaries"
May 3, 1920

Today candidates usually secure their party's nomination during the primary season, and the nominating convention merely provides the party's official stamp of approval. In 1920, however, when the primary process was still new, it did not produce a clear winner for the Republican Party. As the Republican convention neared, there was no front-runner for the G.O.P. Presidential nomination. This cartoon shows the frazzled Republican elephant surrounded by conflicting newspaper headlines while the Democratic donkey makes pressing inquiries. In June, a month after this cartoon was published, the Republican convention in Chicago deadlocked. After numerous meetings and secret discussions held in the smoke-filled rooms of the Blackstone Hotel, Senator Warren G. Harding emerged victorious and handily won the 1920 Presidential election.

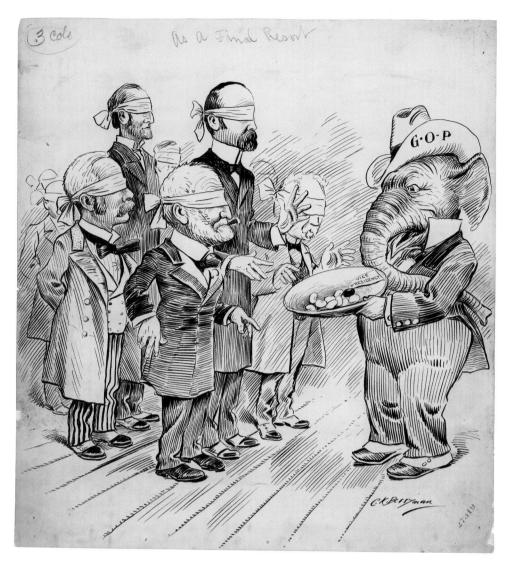

"As a Final Resort"

May 15, 1904

The Republicans' clear choice for their Presidential nominee in 1904 was President Theodore Roosevelt, but there was no front-runner for the Vice Presidential spot. In this cartoon, Berryman ponders whether the Republicans will use a lottery system to choose the candidate. Here a blindfolded group of potential Republican Vice Presidential nominees are shown hoping to draw the single black bean—representing the Vice Presidency—from the bowl. In the end, Charles Fairbanks of Indiana, the tall candidate in the front row, won the nomination by vote at the convention and joined Roosevelt on the ticket. In November the Roosevelt-Fairbanks ticket scored an impressive victory over the Democratic ticket of Alton B. Parker and Henry G. Davis.

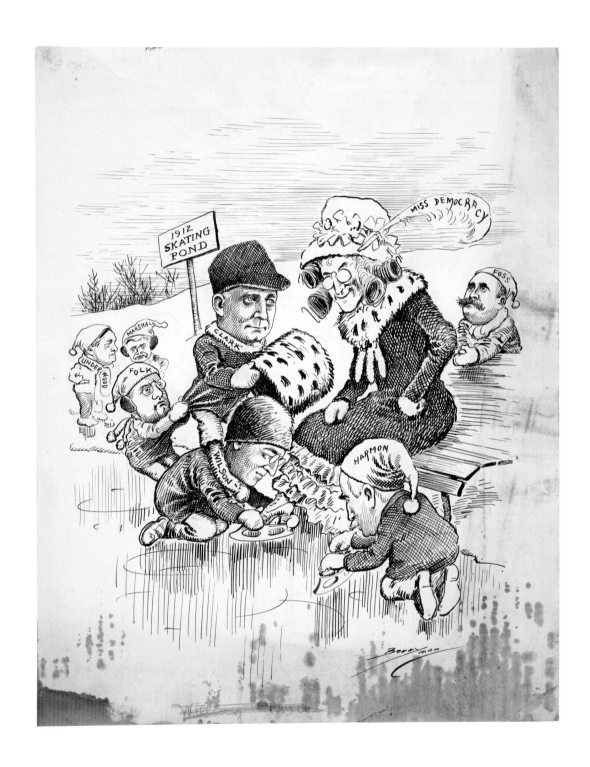

"1912 Skating Pond"
February 5, 1912

Here Miss Democracy is shown being fussed over by a number of Democratic Presidential hopefuls. The larger figures in the center were the front-runners for the Democratic Presidential nomination at that time. They are House Speaker Champ Clark from Missouri, New Jersey Governor Woodrow Wilson, and Ohio Governor Judson Harmon. The candidates in the background—House Majority Leader Oscar W. Underwood from Alabama, former Missouri Governor Joseph W. Folk, Indiana Governor Thomas Marshall, and Massachusetts Governor Eugene Foss—are the long shots in the nomination bid. Berryman drew this cartoon early in the race when no one was certain who would emerge victorious. Wilson eventually won the nomination and was paired with Thomas Marshall as his Vice Presidential running mate.

RUNNING
FOR CONGRESS

Congressional elections differ from Presidential elections in many ways, both in terms of how campaigns are conducted and in the range of issues addressed. Congressional elections often hinge on issues of state or local importance. Equally critical is the way home districts interpret congressional votes on national issues. Members of Congress must carefully balance the desires of their local constituencies with representation at the national level.

Because they are constantly campaigning, members of Congress have to balance time spent legislating in Washington with time spent interacting with their constituents in their home districts. Berryman captured this challenge in many cartoons by depicting members of Congress racing back home to explain their votes and campaign for the next election.

"Congress Will Come to Order!"
December 2, 1912

The ultimate prize of a congressional election is control over the two houses of Congress: the U.S. House of Representatives and the U.S. Senate. This cartoon shows Congress following the pivotal 1912 elections when the Democrats swept into power and captured majorities in both houses.

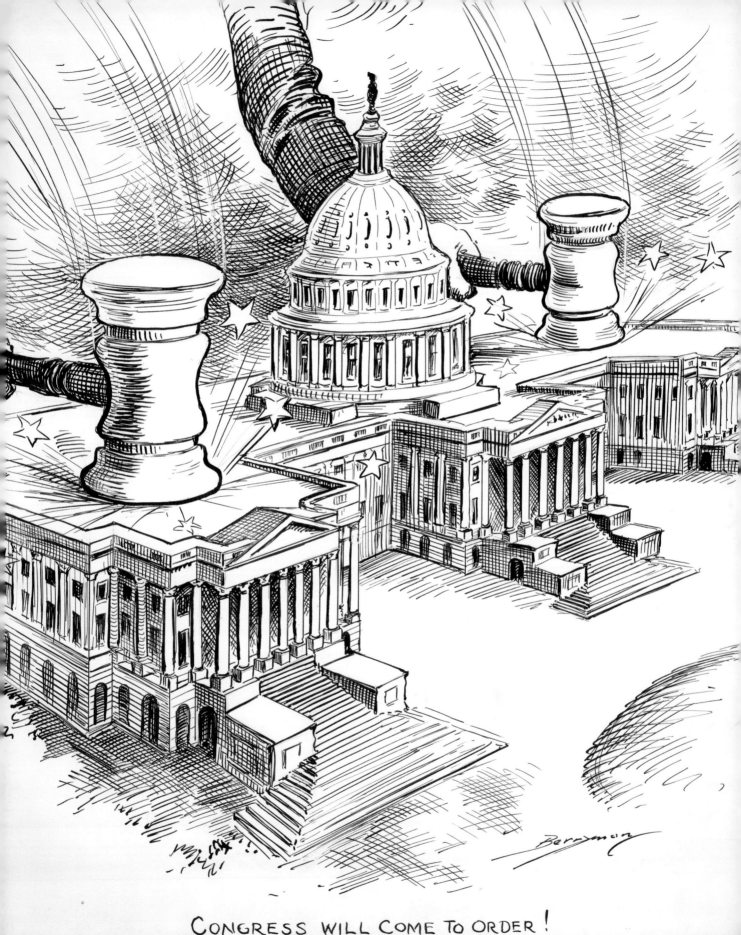

CONGRESS WILL COME TO ORDER !

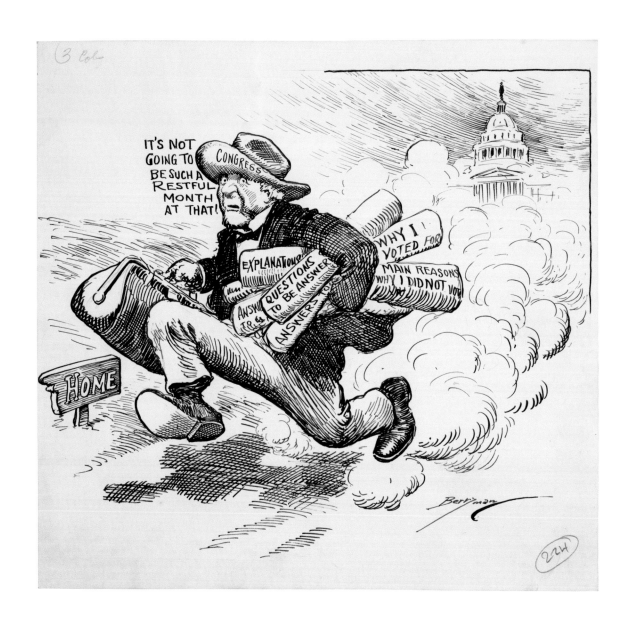

42

"It's Not Going to be Such a Restful Month at That!"
August 25, 1921

This cartoon highlights the never-ending dilemma faced by members of Congress—
explaining votes on various issues to the diverse interests back home. A worried
congressman hurries home with a satchel in his hand and an armload of papers. His
papers provide information on "questions to be answered, explanations, main
reasons why I did not vote, answers to why I voted for…."

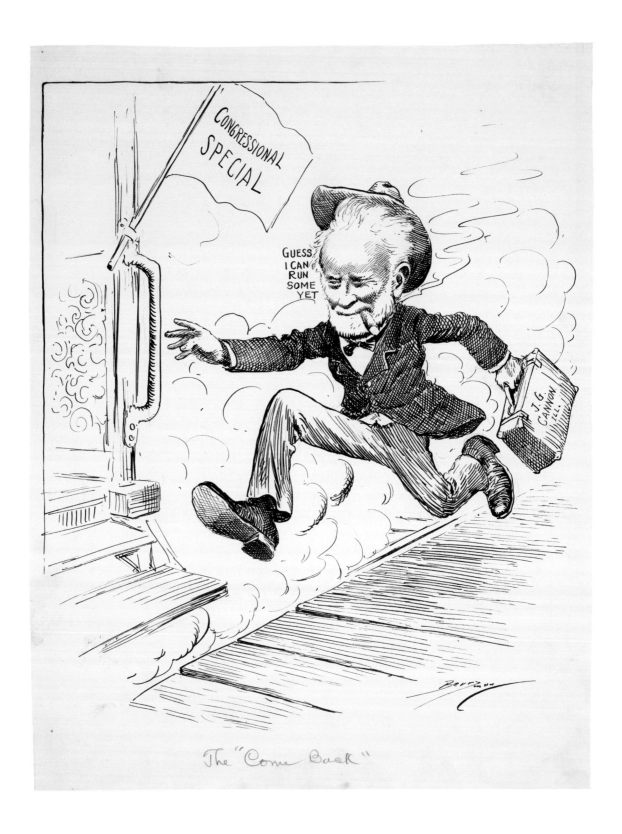

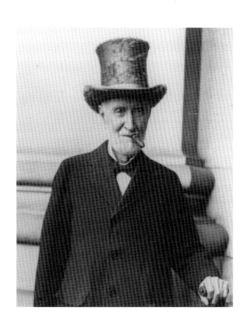

Joseph Cannon
By Underwood & Underwood
Washington, ca. 1921
Prints and Photographs
Library of Congress

***Opposite:* "The 'Come Back'"**
May 25, 1914

Republican "Uncle Joe" Cannon represented Illinois for many years in the House of Representatives.
He served as Chairman of the Appropriations Committee and is perhaps best known for his four
terms as Speaker of the House. By the end of 1909, however, many progressive Republicans had
grown tired of Cannon's iron rule. He was ousted as Speaker in 1910 and lost his reelection bid
in a Democratic sweep of Congress in 1912. This cartoon shows Cannon—with his ever-present
cigar—running toward the "Congressional Special" attempting a "come back" for his House
seat in 1914. Cannon won the election and served in the House until his retirement in 1923.

A common theme in Berryman's cartoons is Congress's jam-packed schedule. As members of Congress rush to conclude business and pass legislation, they inevitably end up meeting beyond their targeted adjournment date. This group of cartoons documents that occurrence during the dramatic second session of the 62nd Congress. The session began on December 4, 1911, and as the 1912 election neared there was no end in sight. "Have You Gentlemen Any Idea When You're To Get Off?" asks Uncle Sam dressed as a train conductor. He is questioning when the House and Senate will adjourn so members can return home to campaign. Congress remained in session for more than a month after the publication of this cartoon.

"Not Yet But Soon" (page 48) shows the difficulty of concluding that lengthy session. Members of Congress were as eager as ever to head home to campaign for reelection and garner support for their party's Presidential candidate. As Berryman shows in this cartoon, the congressman with a bag labeled "hurry—calls from home" is pulled back into the Capitol by a threat of filibuster. In fact, there were two threats of filibuster—a resolution on campaign finance and the House's refusal to accept the Senate's amendments to the general deficiency bill—that held up Congress's adjournment, but ultimately no filibuster occurred. After a weekend all-night session to work out differences, Congress finally adjourned on August 26. Berryman captured the conclusion of the 62nd Congress in "Freed at Last" (page 49). In his drawing the constraining rope of filibuster is severed, and the congressman is finally free to return home and campaign; unfortunately he has missed his train after one of the longest and most laborious sessions on record.

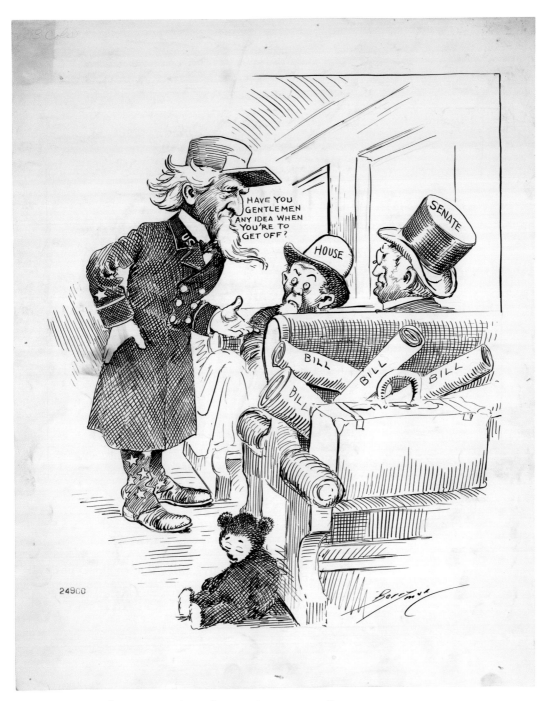

"Have You Gentlemen Any Idea When You're To Get Off?"
July 26, 1912

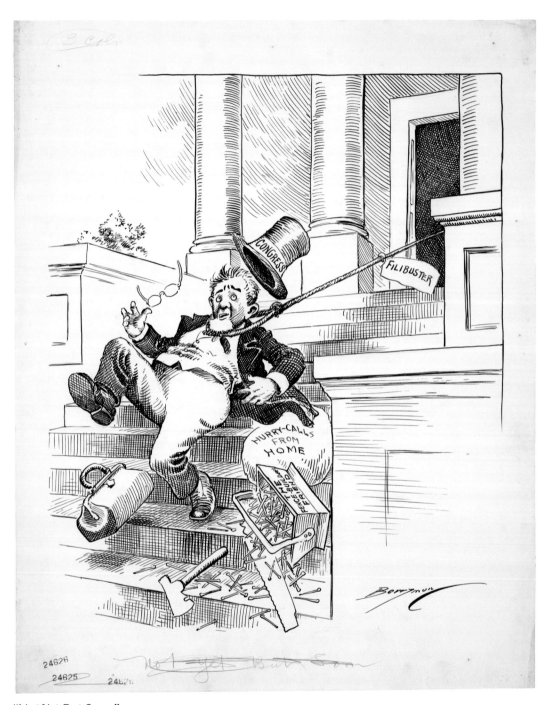

"Not Yet But Soon"

August 26, 1912

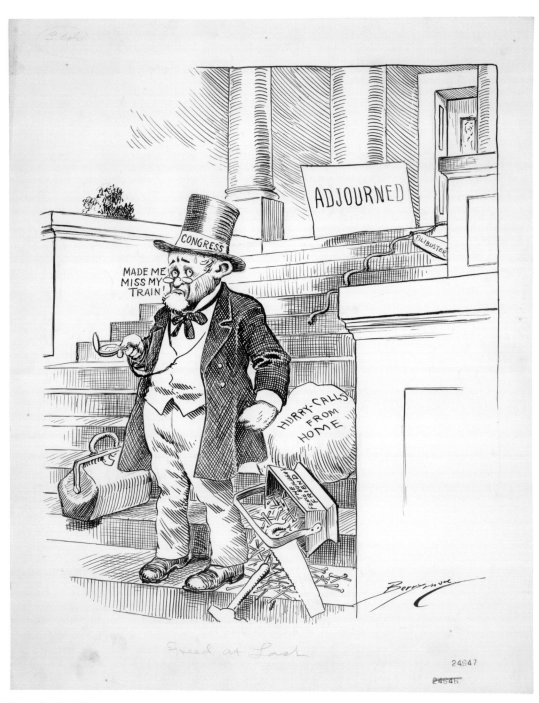

"Freed at Last"

August 27, 1912

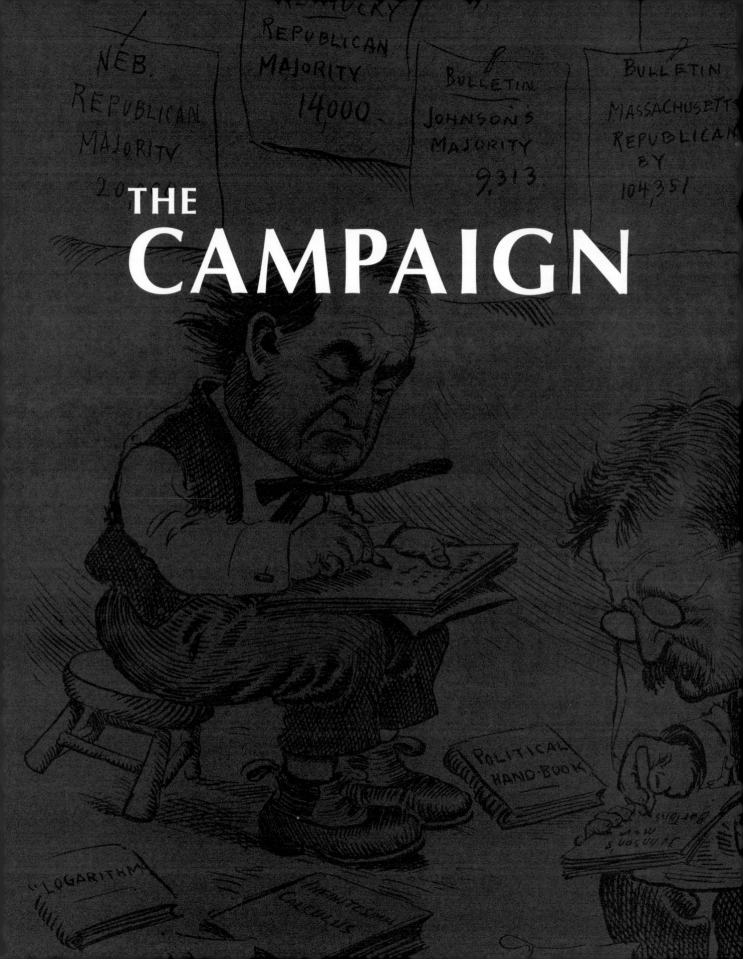

THE CAMPAIGN

Although candidates, issues, and party priorities change, the basic campaign process remains largely the same from year to year. Campaign strategists begin planning for an election immediately after the previous election is over. When candidates declare an official bid for election, they begin the phase of the campaign process that is most familiar to us—debates with other candidates, speeches, public appearances, and meetings with voters.

After the election, the cycle begins again as elected officials spend their term in office building their record and championing measures that will, if successful, become the basis of their next campaign. The constant watchful eye of the media, the public, and the opposition often ensures that failures will also become issues in future campaigns. The following cartoons depict various aspects of a campaign from planning to blunders to addressing the voters back home.

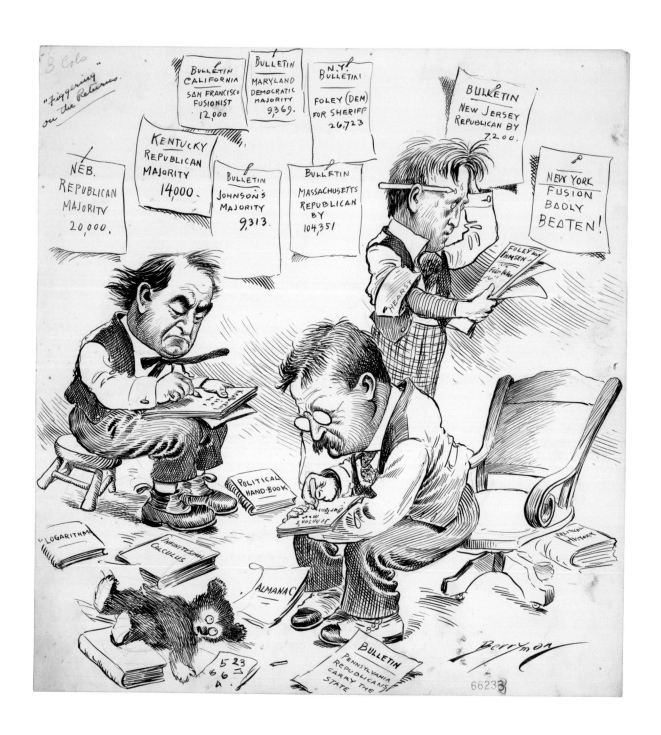

"'Figgering' on the Returns"
November 7, 1907

In this cartoon, William Jennings Bryan, William Randolph Hearst, and President Theodore Roosevelt closely examine the 1907 state and local election returns to try to predict the possible impact these returns may have on their own political futures. The books scattered around the floor suggest that forecasting the consequences that result from an election is as challenging as doing "infinitesimal calculus." Bryan went on to run for President the next year, and Hearst ran for Mayor of New York City in 1909. Roosevelt did not run for reelection and instead went into temporary retirement after his term expired.

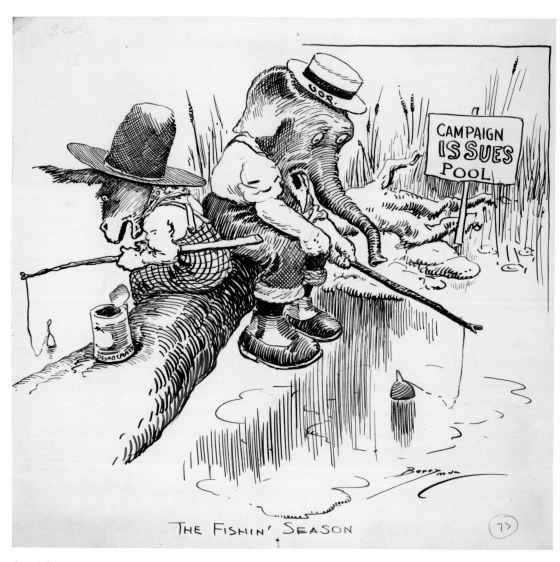

THE FISHIN' SEASON

"The Fishin' Season"
June 7, 1919

When this cartoon was published the 1920 Presidential election was nearly a year and a half away. There were no clear front-runners and both major parties were in need of a campaign platform that would lead their party to victory now that World War I was effectively over and no longer dominated the national agenda. This cartoon captures the Republican elephant and the Democratic donkey seated on the same log fishing on different sides of the "campaign issues pool." The parties did not have to fish long for issues—three weeks after this cartoon was published the Treaty of Versailles was signed, officially ending World War I, and the great political fight over the League of Nations began.

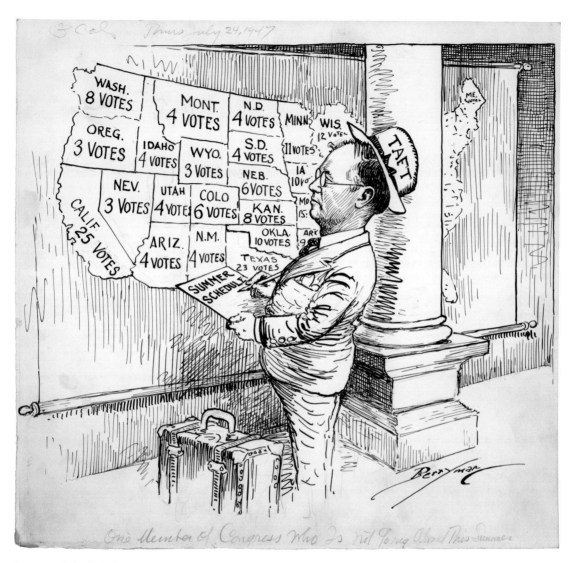

"Summer Schedule"

July 24, 1947

Summer is a critical time for candidates to campaign across the nation in preparation for the primaries the following spring. In this cartoon, Ohio Senator Robert A. Taft—son of former President William Howard Taft—examines an electoral map of the United States while planning his "summer schedule" with the hopes of becoming the next President. Robert Taft, however, had a poor showing in the Republican primaries and at the Republican convention the next summer, lost the nomination to New York Governor Thomas Dewey.

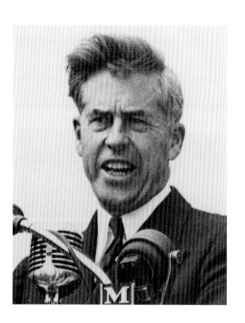

Henry Wallace
By International News, 1944
Records of the Office of War Information
National Archives

Opposite: **"Which of the two Faces is Right, Henry?"**
April 1, 1948

Candidates must identify issues to address in their campaigns and articulate explicit opinions about each issue. This can create problems for candidates who change their opinions, or "flip-flop," from one election to another. In this cartoon printed before the 1948 Presidential election, Progressive Party Presidential candidate Henry Wallace is shown flip-flopping on defense policy. As Vice President during World War II, Wallace staunchly defended military preparedness as a deterrent to war. In 1948, Wallace changed his position and argued that military preparedness would not prevent confrontation. Running as the peace candidate in the early years of the Cold War, Wallace earned no electoral votes and less than three percent of the popular vote in the 1948 Presidential election.

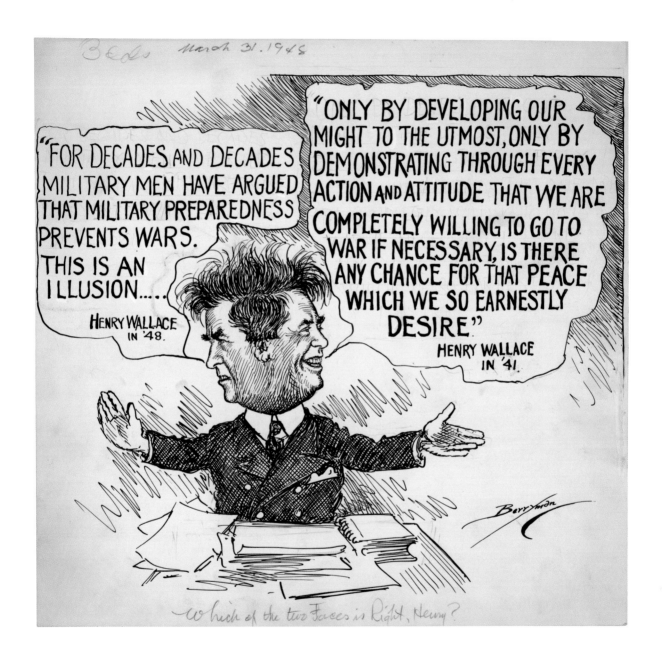

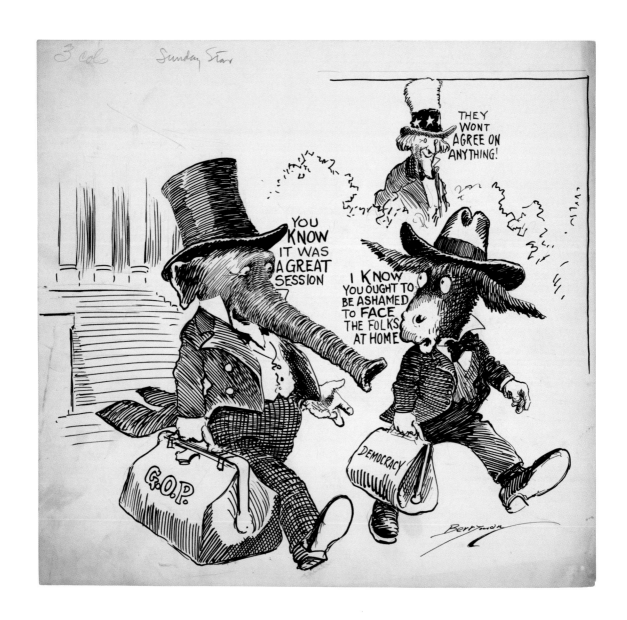

"They Won't Agree on Anything!"
September 24, 1922

The accomplishments and disappointments that occur during a term of office have an impact on future elections. The party in control emphasizes its successes while the minority party calls attention to the majority's policy failures. This cartoon shows Congress adjourning and members returning home to campaign for reelection. As they exit the Capitol, the Republican elephant and Democratic donkey have differing perspectives on the session. The elephant remembers Republican successes while the donkey remembers the Republican majority's failures; each hopes this leads to their party's victory in the upcoming election.

"Campaign Contributions Cause Colossal Crimes"
April 7, 1924

Campaign contributions and expenditures have historically led to controversy. This cartoon references a speech given by William E. Borah, a maverick Republican Senator from Idaho, on the Senate's investigations of corruption in the government and in campaign contributions in particular. Senator Borah used particularly strong language to describe the corruption he saw, calling it "the slinking, secret, sordid enemy" that was undermining the government. He blamed both the Democratic and Republican Parties for taking campaign contributions from those with commercial interests which, he argued, "leads to that sinister and subtle influence which does more to break down the representative government than any specific instance or open bribe." Both the Republican elephant and the Democratic donkey are perplexed by Borah's statements; they ask each other "Do YOU get it?" suggesting that neither of them wants to give up their lucrative campaign fund-raising efforts.

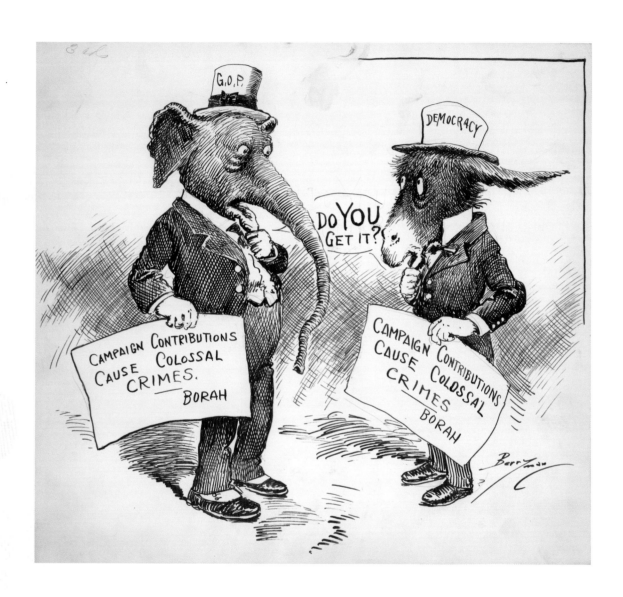

61

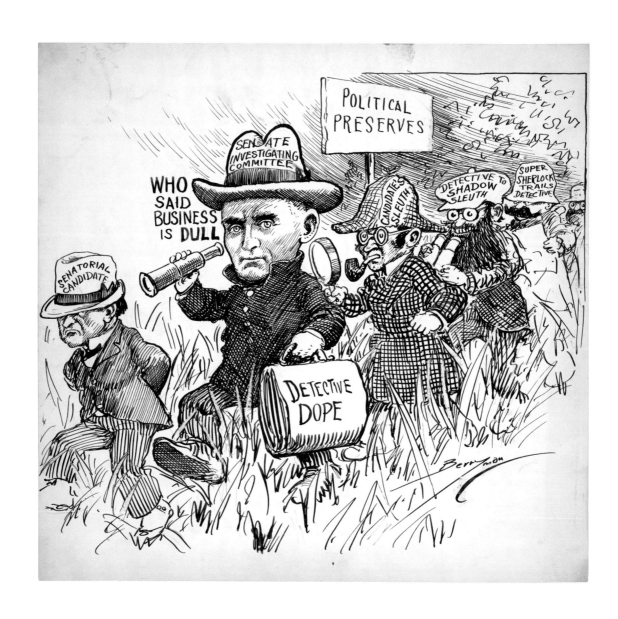

WHO
SAID
BUSINESS
IS DULL

POLITICAL
PRESERVES

SENATE
INVESTIGATING
COMMITTEE

SENATORIAL
CANDIDATE

DETECTIVE
DOPE

CANDIDATES
SLEUTH

DETECTIVE TO
SHADOW
SLEUTH

SUPER
SHERLOCK
TRAILS
DETECTIVE

62

"Who Said Business is Dull"
September 16, 1930

Issues of campaign irregularities brought scandal in 1930. Although Berryman's cartoon may be an exaggeration—with its long line of detectives tailing the senatorial candidate—the 1930 senatorial race was undoubtedly full of intrigue. Ruth Hanna McCormick, Republican senatorial nominee from Illinois, came under investigation for campaign irregularities by the Senate Special Committee to Investigate Campaign Expenditures, led by Senator Gerald Nye of North Dakota. In a series of hearings it was revealed that McCormick had hired detectives to tail suspected agents of the investigating committee. Amid accusations of bribery, break-ins, and shadowing, it became clear that both McCormick and the investigating committee had employed agents to investigate each other, and that the Department of Justice had hired agents to conduct its own investigation.

It is curious that in this cartoon Berryman portrays Ruth Hanna McCormick as a man. Berryman drew women infrequently, and some have speculated that he generally disliked drawing women and lacked confidence in his ability to portray them accurately. This theory is supported by a careful examination of Berryman's cartoons—women are rarely shown, and when they are, with few exceptions, they either look very masculine or their faces are not drawn with much detail.

THE VOTER

Elections revolve around voters. Candidates woo them; campaign issues are tailored to them; parties mobilize them; and democratic governments serve them. In these cartoons, Berryman depicts the wide range of issues that candidates and parties use to entice voters, including lower taxes, improved government services, and the promise of voting rights. Berryman also captures campaigns that failed to engage voters, which, in some cases, occurred because issues of national concern, such as war, overshadowed the election. In other instances, candidates became embroiled in scandals and negative campaigning and lost sight of voters' interests. Even as he noticed the shortcomings of the electoral process, Berryman demonstrated in his drawings a continuing faith in American democracy.

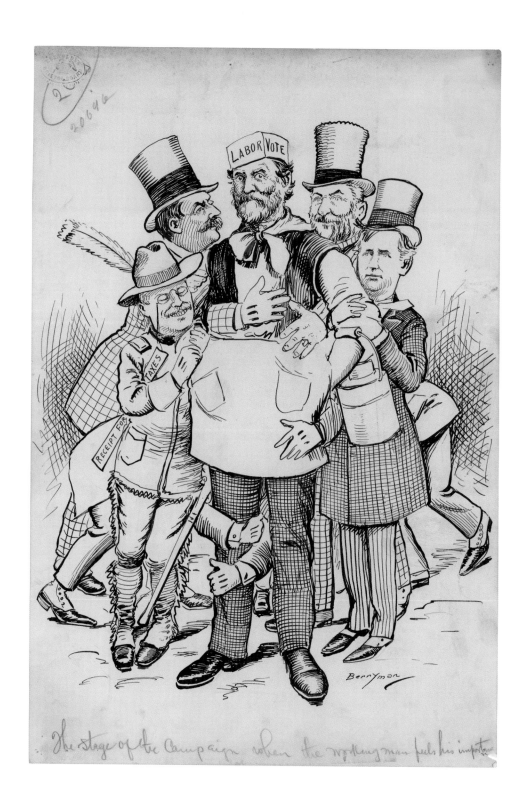

The stage of the Campaign when the working man feels his importance

"The Stage of the Campaign When the Working Man Feels His Importance"
November 2, 1898

Candidates and political parties tend to view the voting population in terms of interest groups.
In this cartoon, politicians, including New York gubernatorial candidate Theodore Roosevelt,
are shown cozying up to the "working man" as the 1898 congressional and state elections
entered the final week. Berryman wryly points out the attention lavished on the labor vote, a
potentially powerful voting bloc in the era of industrialization.

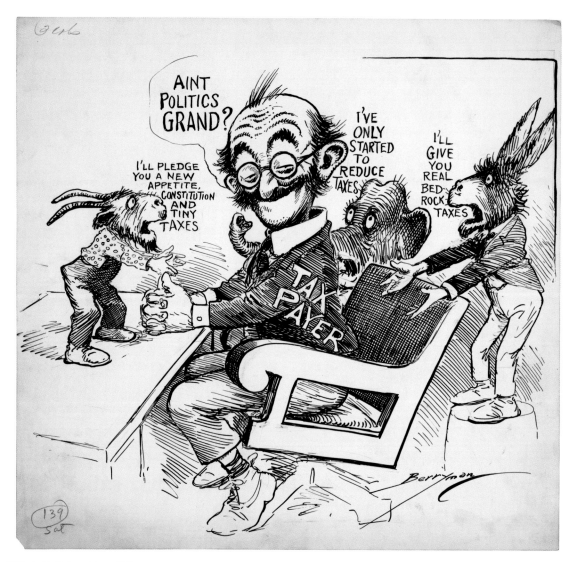

"Ain't Politics Grand?"
October 18, 1924

With the 1924 Presidential and congressional elections only two weeks away, politicians of all parties began to promise lower taxes to woo voters. In this cartoon, "Mr. Tax Payer" revels in all the attention, yet he knows that it is just politics at work. He comments "Ain't politics grand?" as the Republican elephant, the Democratic donkey, and the Progressive goat all try to outdo each other. While the Republican elephant and Democratic donkey were familiar characters, the Progressive goat was a new symbol in 1924. The Progressive Party was created by Robert M. La Follette, Sr., so that he could run for President in the 1924 election. La Follette earned nearly 17 percent of the popular vote but only won electoral votes in Wisconsin, his home state. The party disappeared after the election.

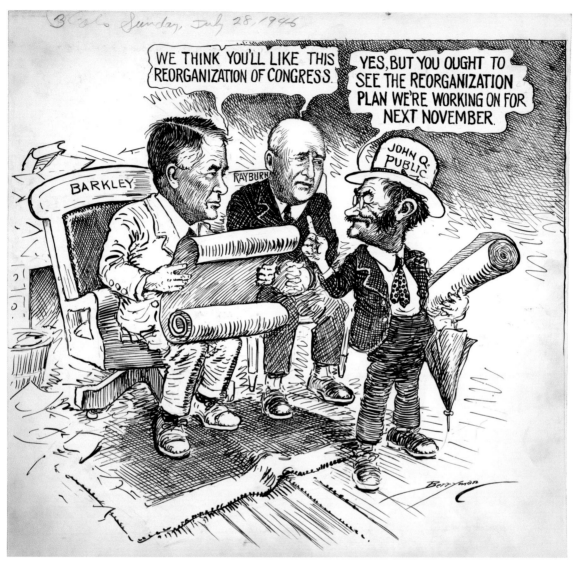

Reorganization of Congress
July 28, 1946

The Legislative Reorganization Act of 1946, the most comprehensive congressional reform in history, modernized Congress and expanded its administrative capabilities. The Democratic leadership in Congress, represented by Senate Majority Leader Alben W. Barkley of Kentucky and House Speaker Sam Rayburn of Texas, hoped that congressional reform would be politically popular. John Q. Public's reply, however, suggested that many voters had a different opinion. In the November elections, the Democrats lost control of both the House and the Senate.

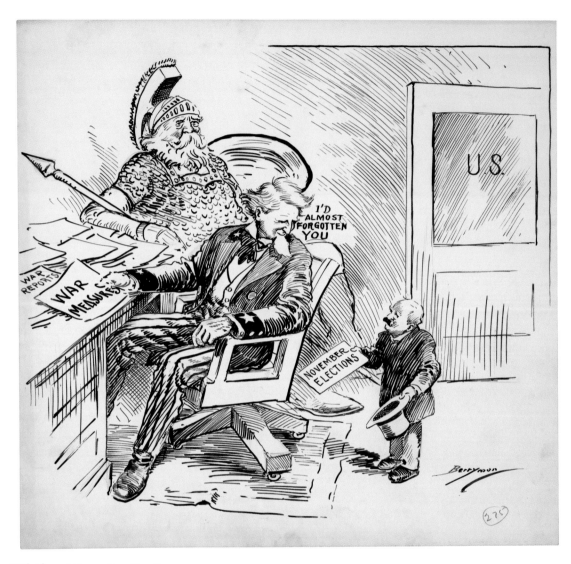

"I'd Almost Forgotten You"
November 5, 1917

Berryman also captures election campaigns that fail to engage the voter. This is sometimes a result of the government's preoccupation with an issue of national crisis—like war. "I'd Almost Forgotten You" was drawn in the midst of World War I. As the war raged, Government officials had little time to think about local and state elections. In this cartoon, the god of war looks on while Uncle Sam peruses reports on the war. A small, almost overlooked figure, representing the voter, interrupts Uncle Sam with a reminder of the impending November elections.

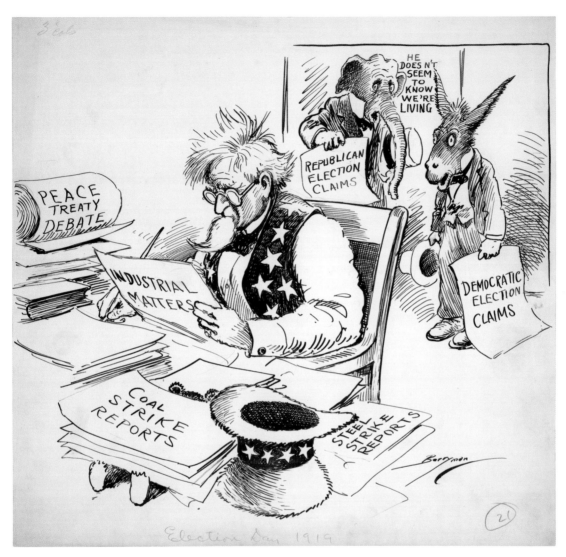

"Election Day 1919"
November 4, 1919

In some instances, candidates become embroiled in scandals and negative campaigning and lose sight of the voters' interests. As World War I ended, debate over the peace treaty took center stage. This debate, coupled with devastating labor strikes in the United States and Great Britain, pushed aside the usual electioneering of the campaign season. Berryman shows the Republican elephant and Democratic donkey wondering why they cannot get their campaign messages heard while Uncle Sam is shown paying attention to more urgent matters.

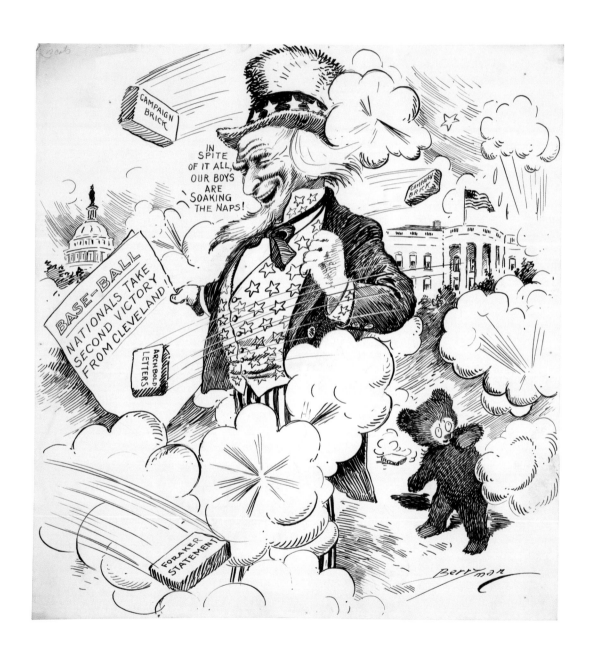

"Campaign Brick"
September 26, 1908

Accusations and scandal characterized the 1908 congressional and Presidential campaigns. In "Campaign Brick," the flying "Archbold" and "Foraker" bricks refer to an election scandal in which Senator Joseph B. Foraker of Ohio was accused of taking bribes from Standard Oil Vice President John D. Archbold. Foraker subsequently lost his reelection bid. Uncle Sam ignores the bricks and focuses on a more positive subject: baseball. The Washington Nationals had just defeated the Cleveland Naps in two straight games.

"The Lady and the Tiger"
November 7, 1917

In this cartoon Berryman presents the two big winners on Election Day 1917 in New York. New York voters adopted a woman suffrage amendment to the state constitution, a measure backed by Tammany Hall, New York City's Democratic political machine. On the same day, Democrat John F. Hylan defeated both the Republican Mayor of New York City John Purroy Mitchel, and Socialist candidate Morris Hillquit. The victory was a major triumph for Tammany Hall, here represented by the proud Tammany Tiger. While some states allowed women to vote, there was no national law guaranteeing women that right. In 1919 Congress proposed a constitutional amendment giving women the right to vote nationwide. This amendment, ratified in 1920, became the 19th Amendment to the U.S. Constitution.

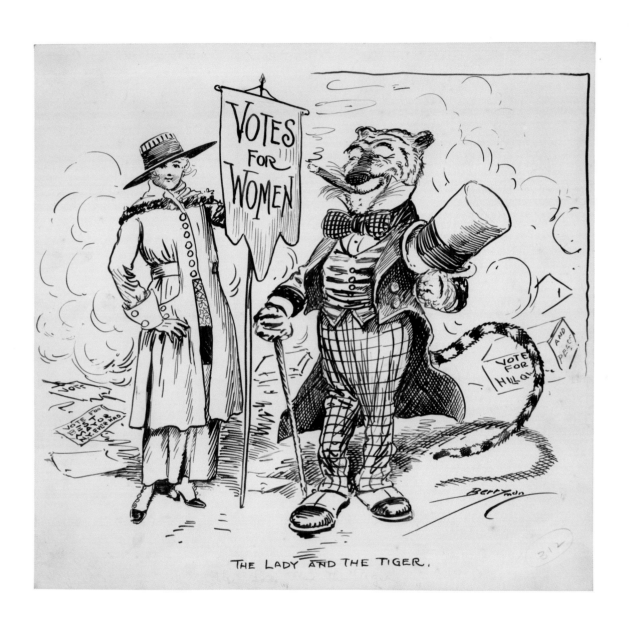

THE LADY AND THE TIGER.

75

WILLIAM JENNINGS

BRYAN

The Perpetual Candidate
1860–1925

William Jennings Bryan was a dominant figure in the Democratic Party for most of his adult life. As a lawyer, a member of Congress, and Secretary of State, Bryan was a renowned orator and a tireless advocate for the rights of the common man. Despite a long and distinguished political career, Bryan is perhaps best known for his many unsuccessful attempts to become President of the United States.

Bryan was the Democratic nominee for President in 1896 and 1900—both times losing to Republican William McKinley. After Democratic candidate Alton B. Parker suffered a landslide loss in the 1904 election, the party again nominated Bryan as their candidate in 1908, this time to run against William Howard Taft. Although Taft ran an uninspiring campaign, Bryan lost by a large margin to him in the general election.

In 1912 Bryan was considered a long shot to be the Presidential candidate, but the Democratic nomination went instead to Woodrow Wilson. Bryan supported Wilson's reelection bid in 1916, but when Wilson decided not to run in 1920, the public incorrectly speculated that Bryan would run again. Despite all of his defeats, speculation continued to turn to Bryan as a possible candidate during nearly every Presidential election season of his professional life.

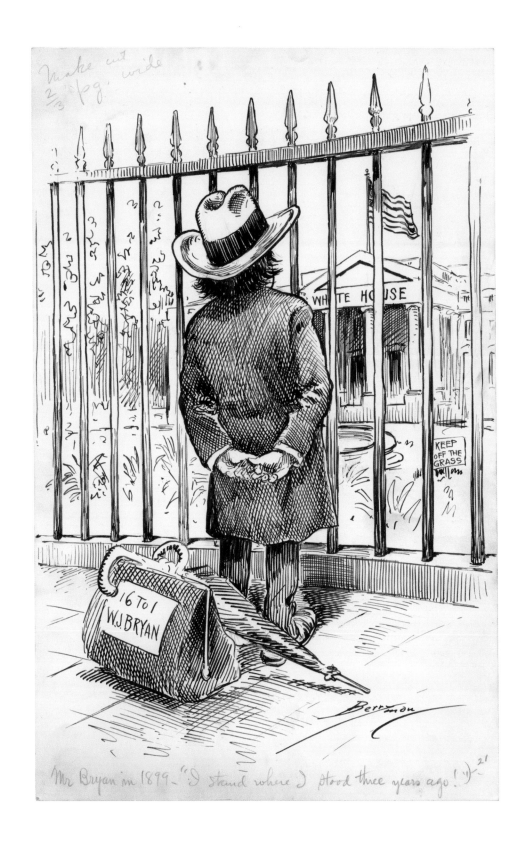

**"William Jennings Bryan Campaigning
for the Presidency, 1896"**
*Records of the U.S. Information Agency
National Archives*

Opposite: **"Mr. Bryan in 1899—'I stand just where I stood three years ago!'"
undated**

William Jennings Bryan is shown staring through the White House fence contemplating a second
run for President. On October 20, 1899, Bryan announced in a speech at the New York Lexington
Hotel that during his 1896 campaign he stood for free silver at a ratio of 16-1 and asserted that "I
stand today where I stood then." This cartoon plays on those words: Bryan, who had lost the 1896
election, is standing in the same place—outside the gates of the White House looking in. Berryman's
cartoon proved prophetic—Bryan lost the Presidential election in 1900.

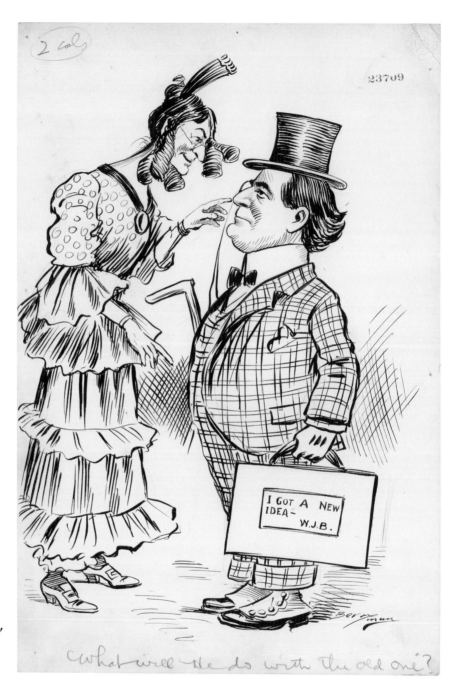

"I Got A New Idea"
January 17, 1904

In 1896 and 1900, Bryan ran unsuccessfully as the Democratic nominee for President, losing both times to Republican William McKinley. In 1904, believing the Democratic Party was unlikely to give him a third chance, Bryan came up with a new idea—to run for the U.S. Senate. Fellow Nebraskan Charles Dietrich planned to vacate his Senate seat, and Bryan hoped to convince the state legislature, who at that time elected senators, to select him. In the cartoon Bryan is telling the American people—represented by Miss Democracy—about his new idea.

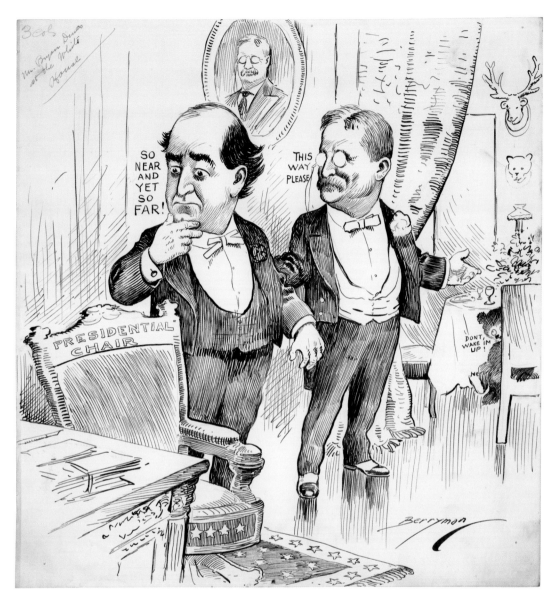

"So Near and Yet So Far!"
May 13, 1908

"So Near and Yet So Far" shows William Jennings Bryan attending a State Dinner at the White House hosted by departing President Theodore Roosevelt. Bryan, who would soon secure the Democratic nomination for President, is shown looking longingly at the Presidential chair. Roosevelt tries to guide the fixated Bryan back to the dining area, while the teddy bear comments on Bryan's Presidential dreams. Bryan won the Democratic Presidential nomination but lost to Roosevelt's hand-chosen successor William Howard Taft in the general election.

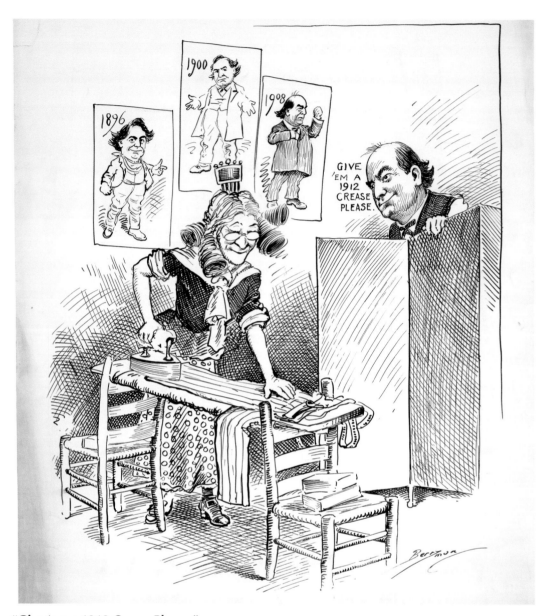

"Give 'em a 1912 Crease Please."
January 26, 1912

In preparation for the 1912 Democratic convention, Bryan spent the winter of 1911–12 on a speaking tour of the country. While Bryan was not expected to receive the Democratic nomination, he wanted to be considered in case the convention deadlocked. Here Bryan waits behind the screen while Miss Democracy presses his trousers. With those instructions and the images of his past campaigns hanging on the wall, Berryman suggests Bryan is preparing for a fourth Presidential bid. When it became apparent that Bryan would not get the nomination, he threw his support behind Woodrow Wilson, who won the Presidency in 1912 and again in 1916.

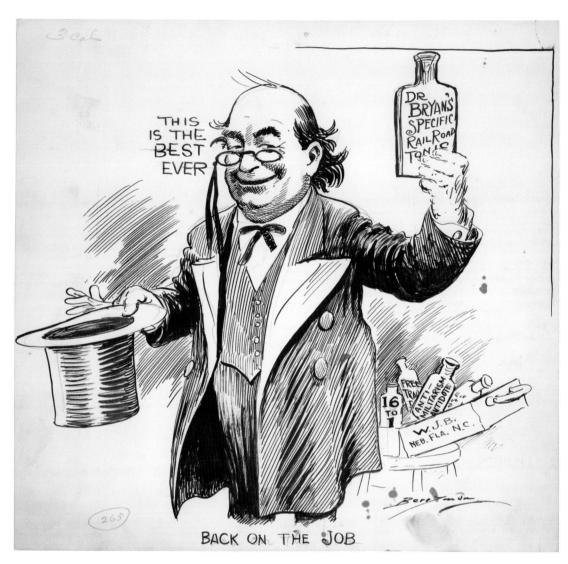

"Back on the Job"
August 30, 1919

Near the end of his second term as President, Woodrow Wilson faced dwindling support and declining health. Nevertheless, Wilson remained ambivalent about his plans to seek an unprecedented third term. This made it difficult for potential Democratic candidates to declare their intentions to run—few wanted to challenge the sitting President from their own party. William Jennings Bryan, however, had never been shy about making his Presidential ambitions known. In "Back on the Job" Bryan is shown peddling his "wares"—his campaign issues—to the public. Bryan proudly displays his new strategy: "Dr. Bryan's Specific Railroad Tonic." On August 29, 1919, Bryan testified before the House Committee on Interstate Commerce describing a plan for ownership of the U.S. railroads. This testimony further fueled public speculation that Bryan would enter the Presidential race.

"William Jennings Bryan appears tired during the 13ᵗʰ day of the Democratic Convention at Madison Square Garden, 1924"
By United Press International, 1924
Records of the U.S. Information Agency
National Archives

Opposite: **"How His Voice Has Changed!"**
March 4, 1920

By March 1920, Bryan had publicly announced he did not desire the Democratic Presidential nomination. But, as a three-time party nominee with two additional attempts seeking his party's nomination, his announcement was received with skepticism. An old-fashioned record player, known as a Victrola, spreads his message. Bryan was ultimately not a candidate for the nomination in 1920. Instead the Democrats nominated James M. Cox, Governor of Ohio, who lost the Presidential election to Republican Warren G. Harding.

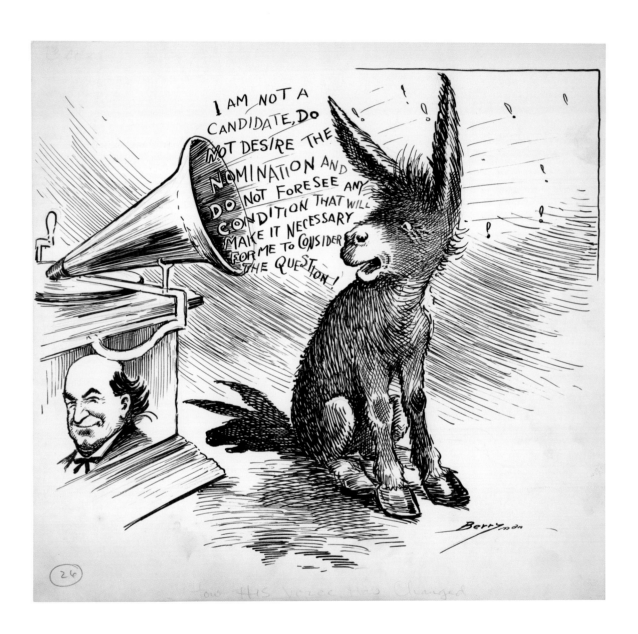

THE
HOMESTRETCH

These cartoons, printed during the final days, weeks, and months of various campaigns, capture the frantic candidates as Election Day fast approaches. With little time left, candidates face the anxieties that come with victory or defeat. But no matter how daunting the challenges may be, candidates must put on a brave face for the public. Berryman captures the underlying angst candidates feel as the campaign draws to a close.

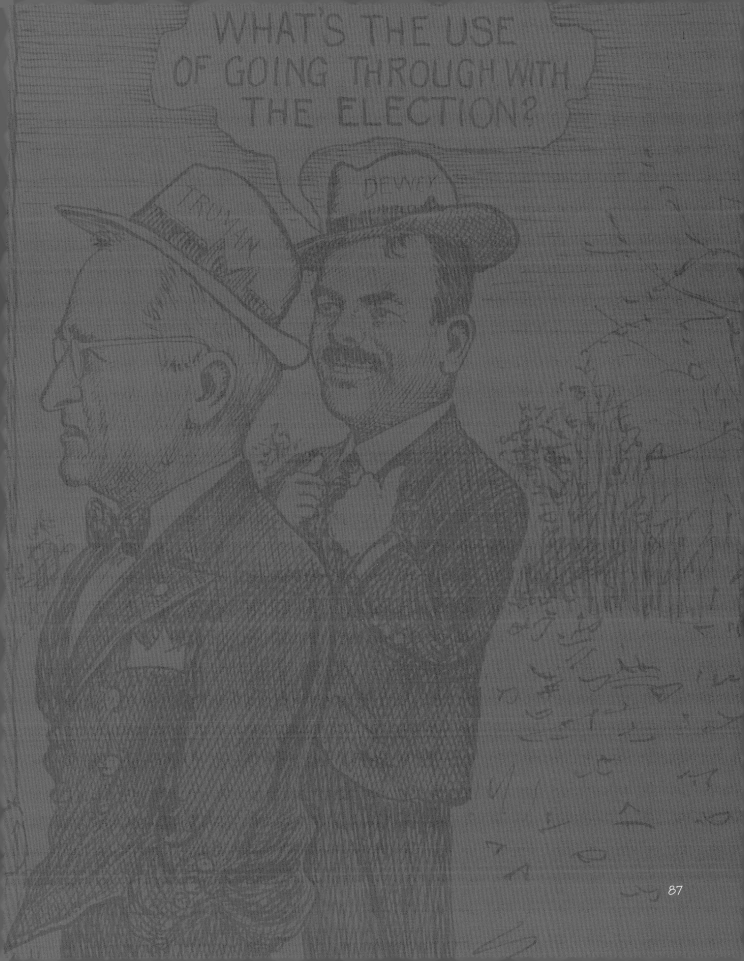

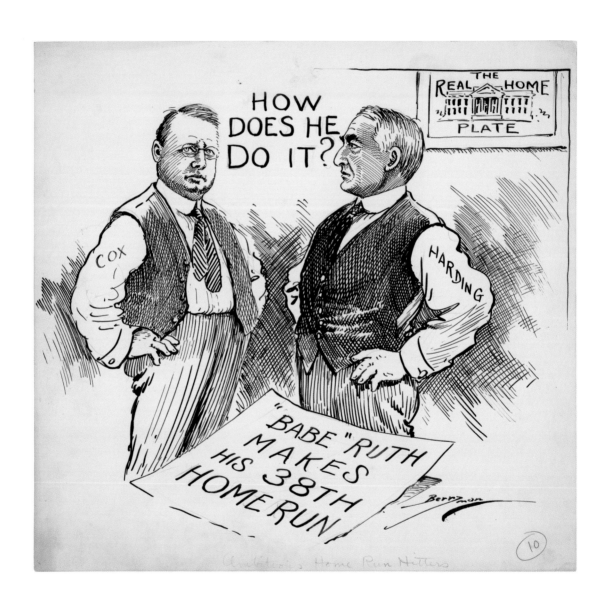

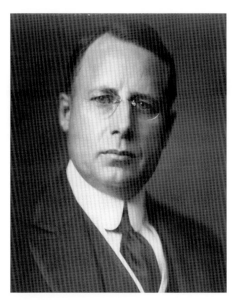

James M. Cox, ca. 1920

Prints and Photographs

Library of Congress

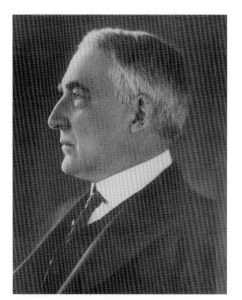

Warren G. Harding, ca. 1921–23

Records of the Bureau of Reclamation

National Archives

Opposite: **"Ambitious Home Run Hitters"**

August 3, 1920

In late summer 1920 the Presidential contest between Democratic nominee James M. Cox and Republican nominee Warren G. Harding was beginning to intensify. However, the dominant news story was not the campaign—it was baseball sensation Babe Ruth's unstoppable first season with the New York Yankees. In this cartoon both Presidential candidates are shown pondering Ruth's secret of success with the White House being their "real home plate." Harding hit a "home run" in the November elections and beat Cox by a landslide.

"Anti-Third Term Principle"
October 1, 1912

After winning the 1904 election, President Theodore Roosevelt announced that he would honor
the two-term tradition by not running for reelection in 1908. The pledge haunted Roosevelt, espe-
cially when he decided to seek the Presidency again in 1912. This cartoon, published one month
before the election, shows the ghost of George Washington reminding Roosevelt of his past prom-
ise. Because Roosevelt's terms would be non-consecutive, his supporters felt that in this case a
third Presidential term would not violate the spirit of the two-term tradition. However, just two
weeks after this cartoon appeared on the front page of the *Washington Evening Star*, Roosevelt was
shot by a fanatic supporter of the term limit. Roosevelt was not seriously wounded, and he contin-
ued his campaign for a third term. The issue, however, became moot when Roosevelt lost the elec-
tion to Woodrow Wilson.

George Washington began the two-term tradition by retiring as President after his second term. The
tradition was tested in 1880 by Ulysses S. Grant and in 1912 by Theodore Roosevelt, but it
remained unbroken until Democratic President Franklin Roosevelt won a third and fourth term in
the White House in 1940 and 1944. In 1947, Congress proposed the 22nd Amendment amid
concerns that without limits, the Presidency could become a dictatorship which lasted a lifetime.
The 22nd Amendment, ratified by the necessary three-fourths of the states in 1951, codified the
two-term tradition for the Presidency.

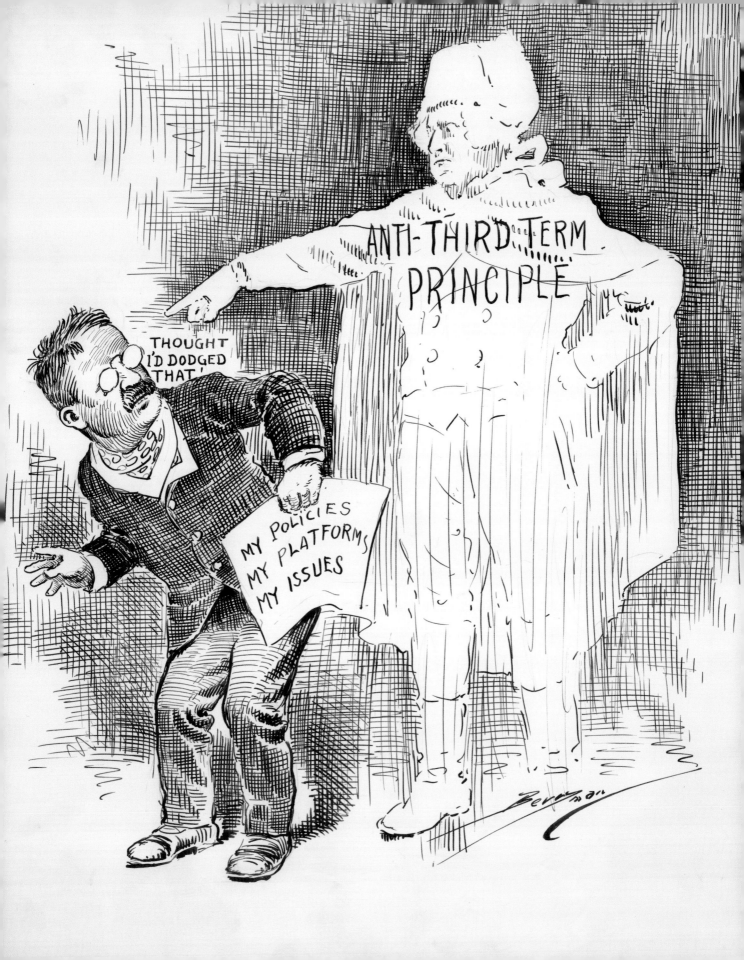

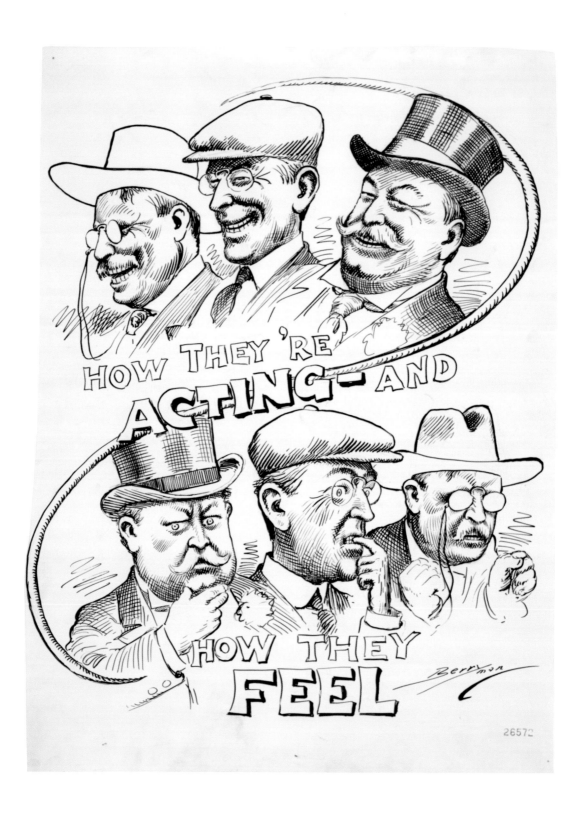

HOW THEY'RE ACTING—AND HOW THEY FEEL

"How They're Acting—and How They Feel"
November 5, 1912

Berryman often drew cartoons that showed candidates' anxieties on the eve of important elec-
tions. "How They're Acting—and How They Feel" shows the three Presidential candidates on the
eve of the contentious 1912 election: former President Theodore Roosevelt for the Progressive
(Bull Moose) Party, Woodrow Wilson for the Democratic Party, and incumbent President William
Howard Taft for the Republican Party. The cartoon reveals the anxiety underneath the confident
public persona each candidate projects. Wilson won the election when Roosevelt and Taft split
the Republican vote.

"On the Home Stretch"
November 7, 1904

In "On the Home Stretch" Berryman draws attention to the overwhelming confidence portrayed by the Democratic Party on the eve of the 1904 Presidential election. Judge Alton B. Parker, the Democratic candidate, boldly challenged the very popular incumbent Theodore Roosevelt. Throughout Judge Parker's campaign his supporters professed great certainty that he would win. Despite polls indicating Roosevelt's lead, the Democrats confidently claimed the "silent vote" would ensure Parker's victory on election day. Ultimately the Republicans had nothing to fear, and Roosevelt won by a landslide.

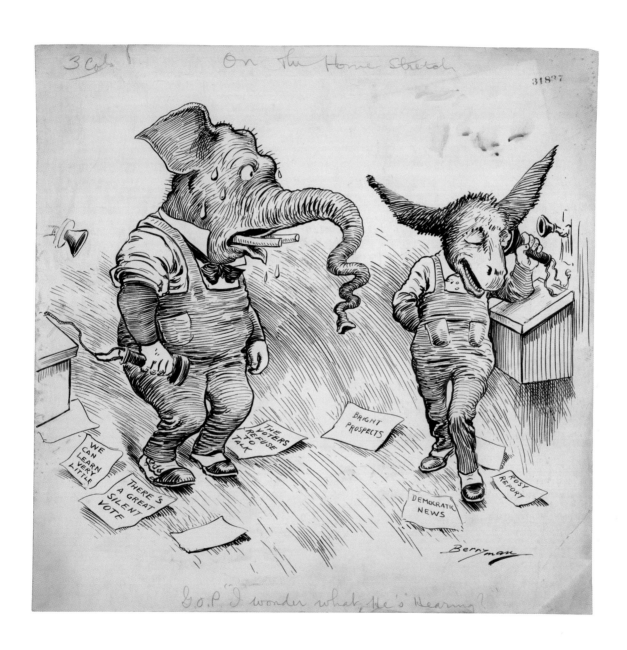

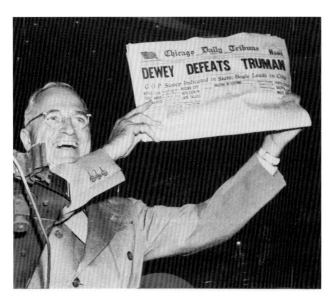

Dewey Defeats Truman

By United Press, 1948

Records of the U.S. Information Agency

National Archives

Opposite: **"What's the Use of Going Through with the Election?"**
October 19, 1948

President Harry S. Truman, the Democratic Presidential nominee in the election of 1948, was widely expected to lose by a large margin to Republican nominee Thomas E. Dewey. This cartoon, printed just days before the election, shows Dewey confidently looking over the shoulder of a frowning Truman as they read bulletins showing the prevailing public opinion of the time. Despite several polls predicting a landslide victory for Dewey, Truman won the election in one of the biggest and most well-known political upsets in U.S. history. Journalists at the *Chicago Daily Tribune* were so convinced that Dewey would win that they prematurely printed the headline "Dewey Defeats Truman" on the front page of their newspaper.

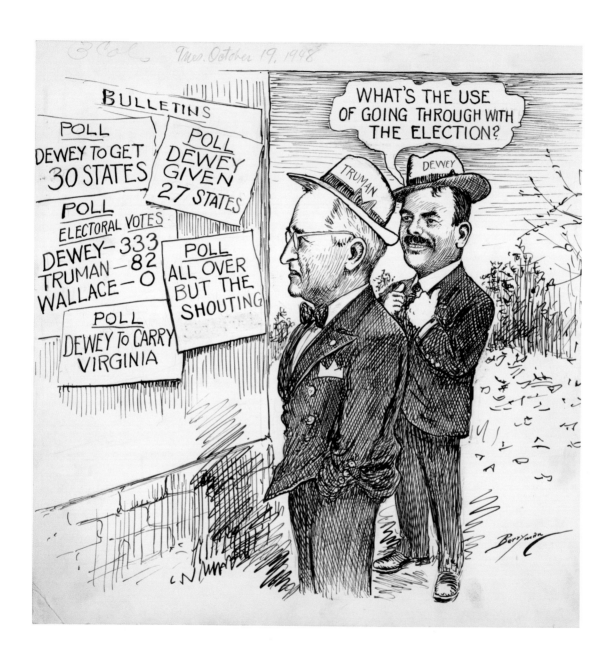

ELECTION

THE
RESULTS
ARE IN!

CONTROL OF CONGRESS

The results of an election can alter the political landscape of the nation. Who the voters elect to office affects candidates, political parties, policies, the government's balance of power, and the American people. A congressional election that yields a new majority in Congress can alter the influence of both major parties, reorganize the institutional leadership, and change the legislative agenda. A change in the Presidency can cause a major reorganization of the executive branch and a drastic shift in both foreign and domestic policy. Although these political and institutional changes are of great importance, they are not always the primary focus of the media in the immediate aftermath of an election. In the following cartoons Clifford Berryman captures the impact of election results on both the winners and the losers.

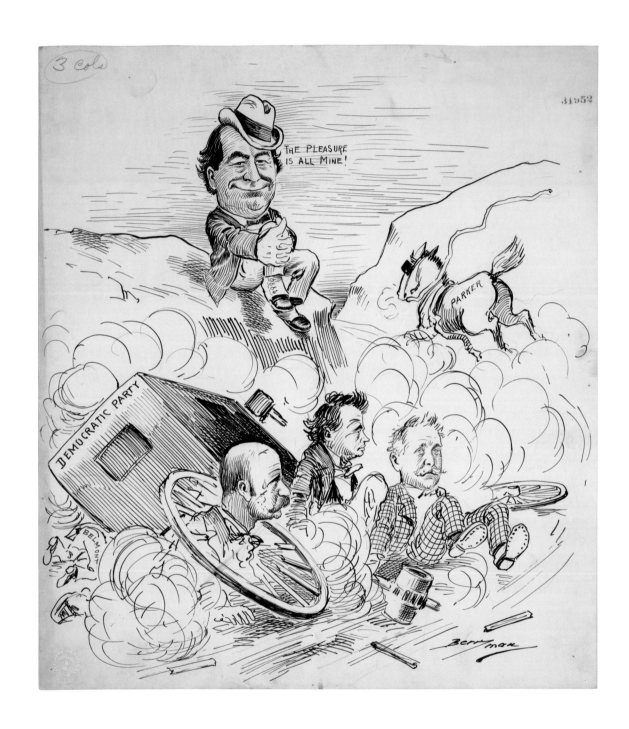

"The Pleasure Is All Mine!"
November 10, 1904

When Democrat Judge Alton B. Parker lost the Presidential election in 1904 to the incumbent Republican President Theodore Roosevelt, fellow Democrat William Jennings Bryan should have felt disappointed. But in this cartoon, printed two days after the election, Bryan is shown gloating as Parker and the Democratic Party collapse in shambles. The figures in the midst of the wreckage represent Parker's conservative backers who had temporarily seized control over the Democratic Party. Bryan had lost the Democratic nomination to Parker, and his pleasure comes from seeing the defeat of his former competitor and the likelihood that the Bryan faction would regain control of the party.

"Another Such Victory and I'm Undone!"
November 9, 1922

Although the Republicans won the 1920 congressional and Presidential elections by a landslide, by 1922 the Republican Party was fighting desperately to retain control of Congress as the midterm elections approached. The Republicans were prepared to lose some of their seats, but they lost many more than expected and emerged from the election with only a very slim majority in both houses. As the beaten and battered elephant in the cartoon suggests, another attempt to maintain the Republican majority through such a brutal election cycle would likely end in defeat.

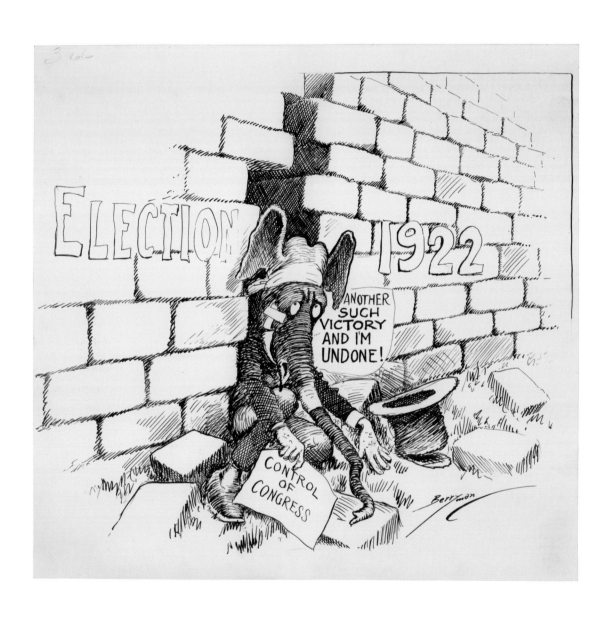

103

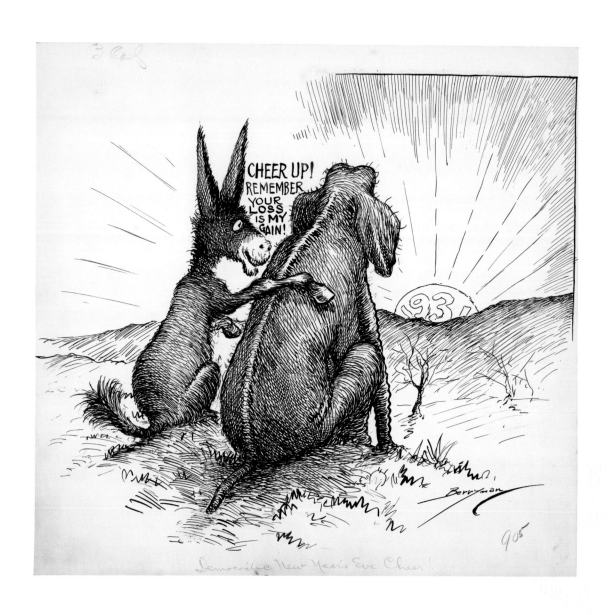

"Democratic New Year's Eve Cheer"
December 31, 1931

In 1930 Republicans again had a slim majority in both houses of Congress going into the midterm elections. But this time they were not able to hold onto it. When the new Congress convened in December 1931, a number of post-election deaths and departures left vacancies in seats held by Republicans. Results from special elections held to fill those seats shifted control of the House of Representatives to the Democrats. The Democratic donkey, cheered by his party's new power, consoles the defeated Republican elephant as the old year sets over the horizon.

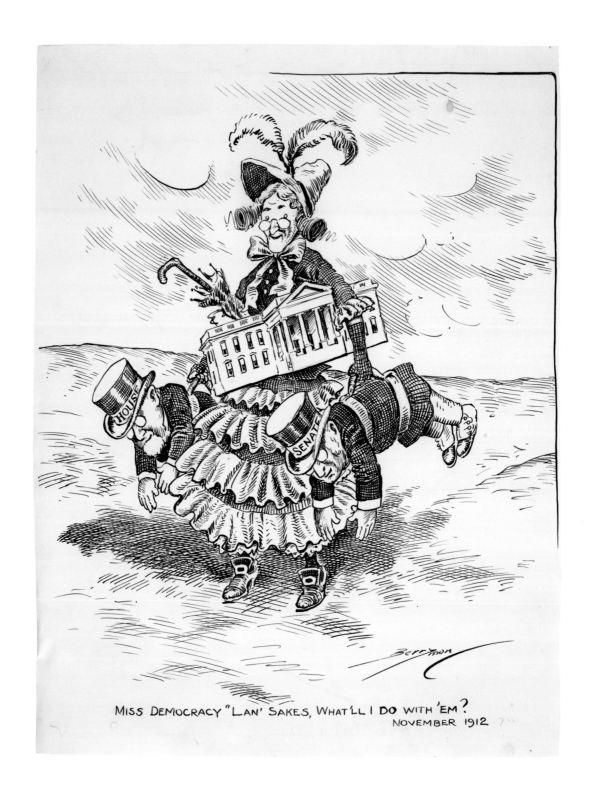

MISS DEMOCRACY "LAN' SAKES, WHAT'LL I DO WITH 'EM?
NOVEMBER 1912

"Miss Democracy 'Lan' Sakes, What'll I Do With 'Em?'"
November 7, 1912

The 1912 elections resulted in a huge victory for the Democratic Party. The Republican vote was split between President William Howard Taft and former President Theodore Roosevelt, which allowed the Democrat Woodrow Wilson to win the Presidency and the Democrats to win a substantial majority of seats in both houses of Congress. A surprised Miss Democracy is shown two days after the election carrying the House and Senate with the White House tucked under her arm; she is wondering what the change in leadership will bring.

"President to Be"
November 8, 1912

This cartoon appeared on the front page of the *Washington Evening Star* on November 8, 1912, just three days after the hotly contested 1912 Presidential election. As soon as Woodrow Wilson's victory was announced, the requests for Presidential appointments started pouring in, and the "President to Be" was inundated with requests for "cabinet slates." Once Wilson took office, he quickly selected party loyalist William Jennings Bryan to be Secretary of State as a reward for Bryan's support at the Democratic convention.

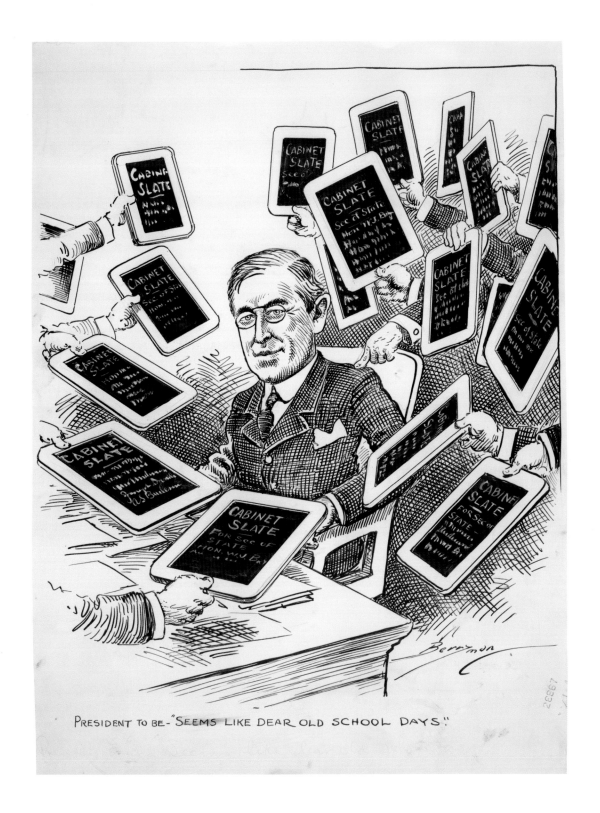

PRESIDENT TO BE — "SEEMS LIKE DEAR OLD SCHOOL DAYS."

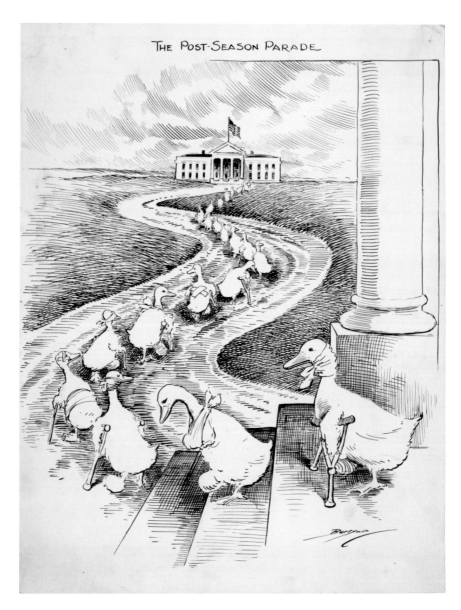

THE POST-SEASON PARADE

"The Post-Season Parade"
March 5, 1915

This cartoon highlights
the biennial departure
of "lame duck" members
of Congress—those who are departing Capitol Hill after losing their bid for reelection. Until the passage
of the 20th Amendment in 1933, elections were held in early November even though the new Congress
did not convene until March and sometimes as late as December of the following year. Departing
members continued to serve for months after the election. The lame ducks in this cartoon are defeated
Democrats heading to the White House hoping to secure political appointments from President
Woodrow Wilson.